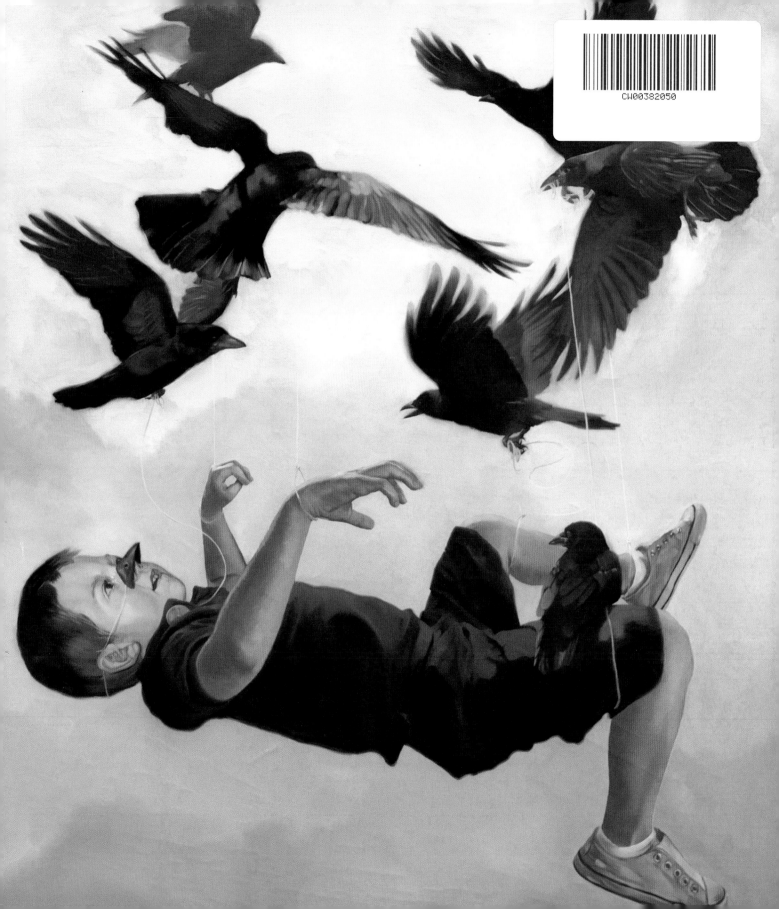

Hand Made
illustration

Copyright © 2011 INSTITUTO MONSA DE EDICIONES

Editor, concept, and project director
Josep Mª Minguet

Author
Art direction, text and layout by
Eva Minguet Cámara
(Monsa Publications)

2011 © Instituto Monsa de Ediciones
Gravina, 43 (08930)
Sant Adrià del Besòs
Barcelona (Spain)
Tel (34) 93 381 00 50
Fax (34) 93 381 00 93
monsa@monsa.com
www.monsa.com
www.monsashop.com

ISBN 978-84-15223-29-0
DL: B-34644/2011

Translation by Babyl
Printed in Spain
by Gayban

Image cover © Brandi Milne
Image backcover © Emma Leonard
Image page 1 © Nate Frizzell
Image page 3 © Clàudia Carrillo
Image page 7 © Melissa Contreras
Image page 8-9 © Sabine Pieper

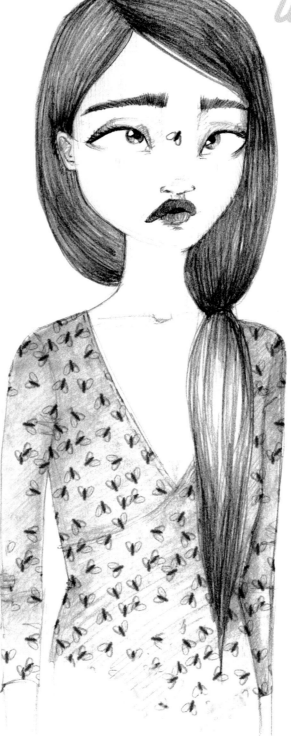

Index

p_6

Intro

p_10

Erika Yamashiro

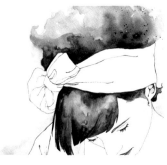

p_18

Emma Leonard

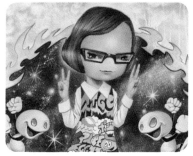

p_24

Yosuke-Ueno

p_32

Denise Van Leeuwen

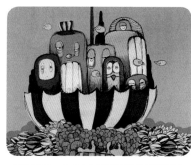

p_38

Siz Mano

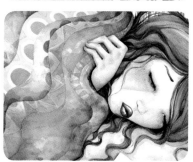

p_44

Melissa Contreras

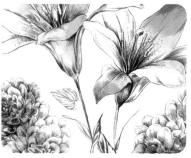

p_52

Esra Roise

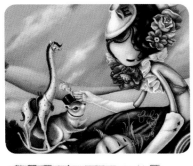

p_58

Brandi Milne

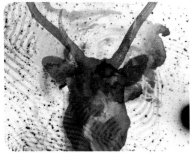

p_68

Tetsuya Toshima

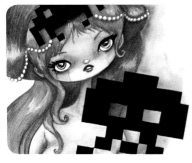

p_76

Daisy Church

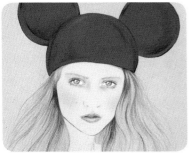

p_84

Kelly Thompson

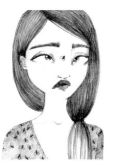

p_90

Clàudia Carrillo

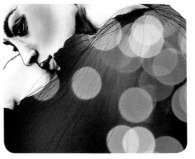

p_96

Sabine Pieper

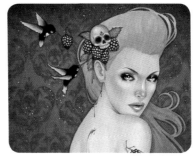

p_102

Glenn Arthur

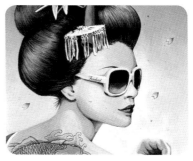

p_110

Kaoru Sauda

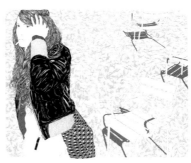

p_116

Carine Brancowitz

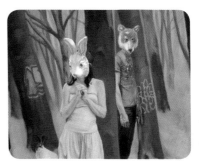

p_122

Nate Frizzell

Intro

Illustrators are increasingly turning to digital illustration, relying on most popular software such as Photoshop and Illustrator, but... whatever happened to all the tools we've relied on for years, paintbrushes, pencils and pens, not to mention the hands?
We've come across countless artists who prefer to soil their hands, dispense with the computer and create their own unique works of art. Artists such as these continue to create exclusive artworks, materialized from remnants, woods, elements, in short, one offs.

We have chosen to present a collection of artworks, specially selected by artists, from different backgrounds, who adopt various techniques to create these pieces. Every profile is accompanied by a brief interview to get a closer idea of the artist's work and techniques.

We hope you are as equally stimulated as ourselves by our choice of up-and-coming, united artists.

Cada vez más, los ilustradores realizan sus trabajos en ilustración digital, utilizando programas como Photoshop o Illustrator, pero... ¿dónde han quedado las herramientas de toda la vida como pinceles, lápices, bolígrafos o incluso las manos?.
Hemos encontrado infinidad de artistas que prefieren ensuciarse las manos y prescindir del ordenador, dándole a sus trabajos un sentido único. Artistas que siguen haciendo exclusivas sus obras, plasmándolas en retales o maderas, elementos que en definitiva hacen de estas un trabajo irrepetible.

Hemos reunido artistas de todo el mundo, que empleando diferentes técnicas, nos presentan las ilustraciones que ellos mismos han seleccionado. Incluimos una breve entrevista en cada perfil, en la que con un tono cercano podréis conocer mejor su trabajo y técnica.

Esperamos que esta selección de artistas emergentes o consolidados, os resulte tan estimulante como a nosotros.

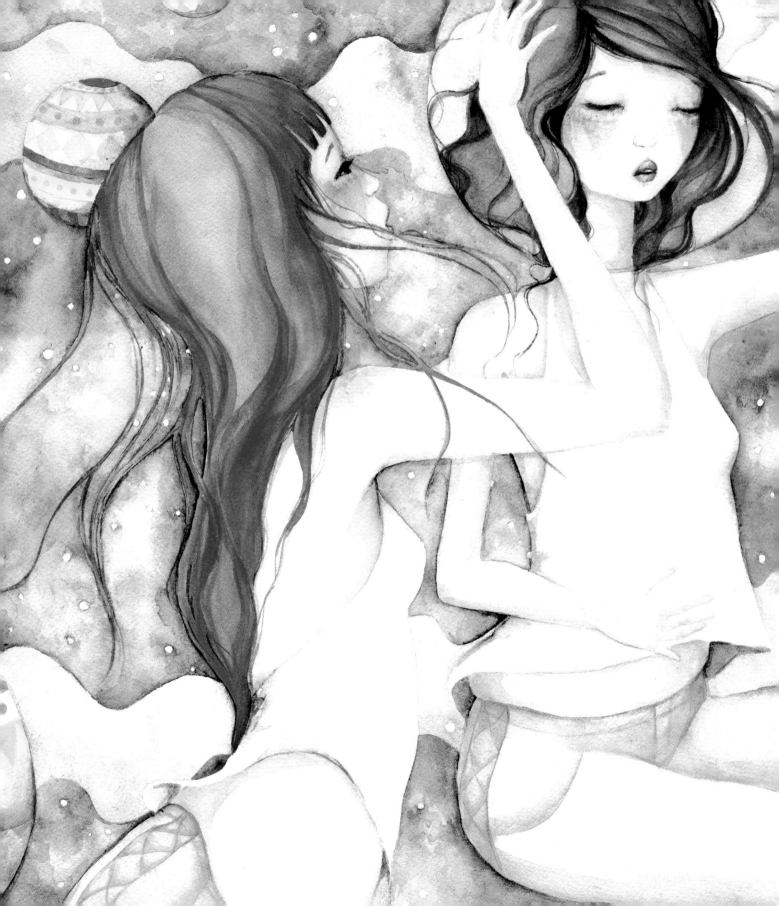

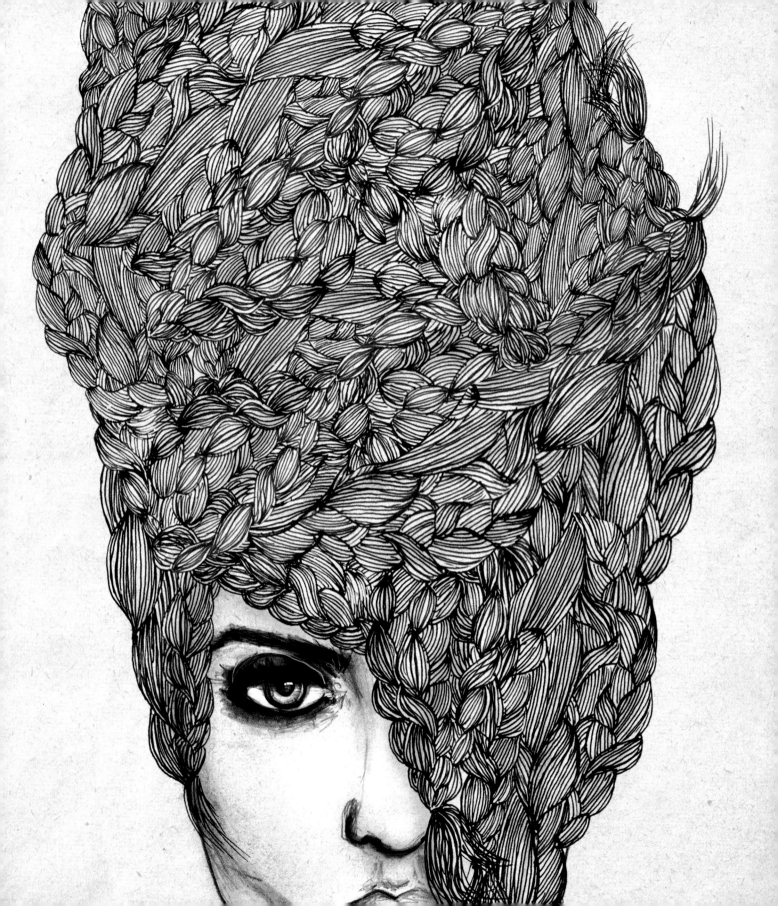

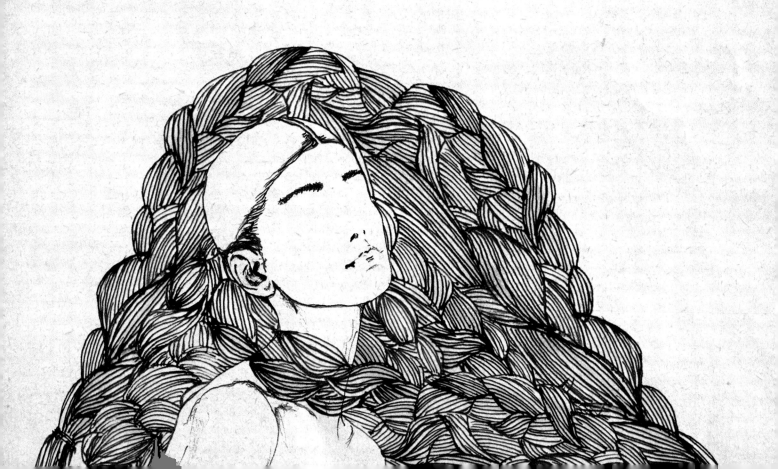

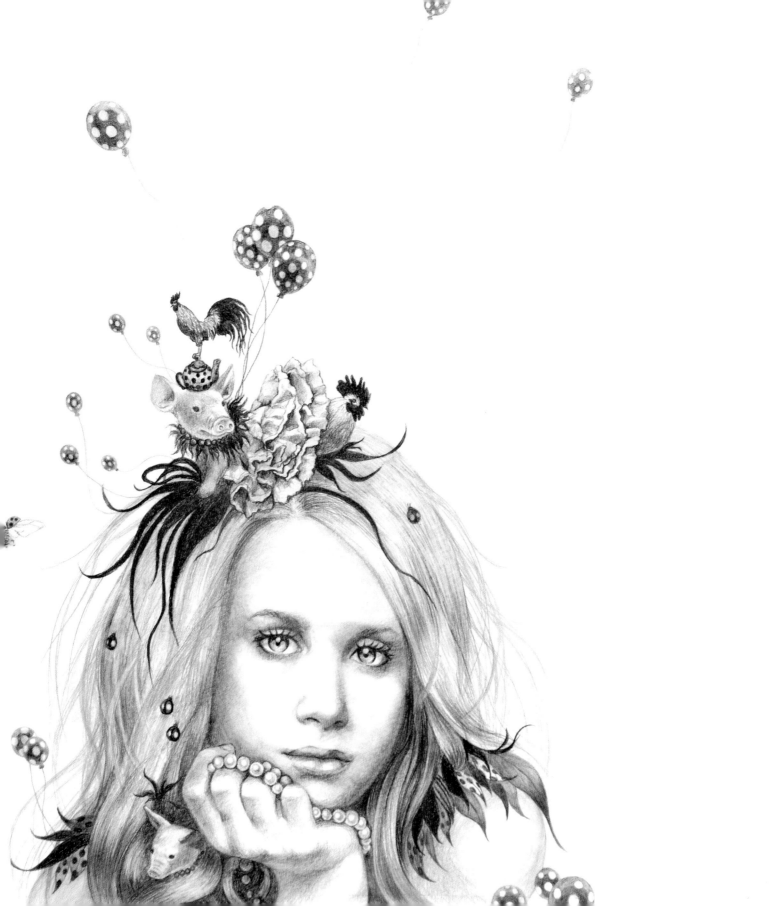

Erika Yamashiro

visit: http://erikayamashiro.com

I mainly use oil and acrylic on canvas.
And I stared drawing since 2010, and I started making lithography since 2011.
My art works are feminine and express some stories.

I use a lot of pink beige. I love the color because I can feel warmness.
When I listen to music and watch the movies, I get inspiration.

Principalmente utilizo óleo y acrílico sobre el lienzo.
Empecé a dibujar en el 2010 y a hacer litografía en el 2011.
Mis obras son femeninas y expresan historias.

Uso mucho el beige rosado, me encanta ese color porque transmite calor.
Me inspiro escuchando música y viendo películas.

p_10
Carnival.
Pencil on paper.

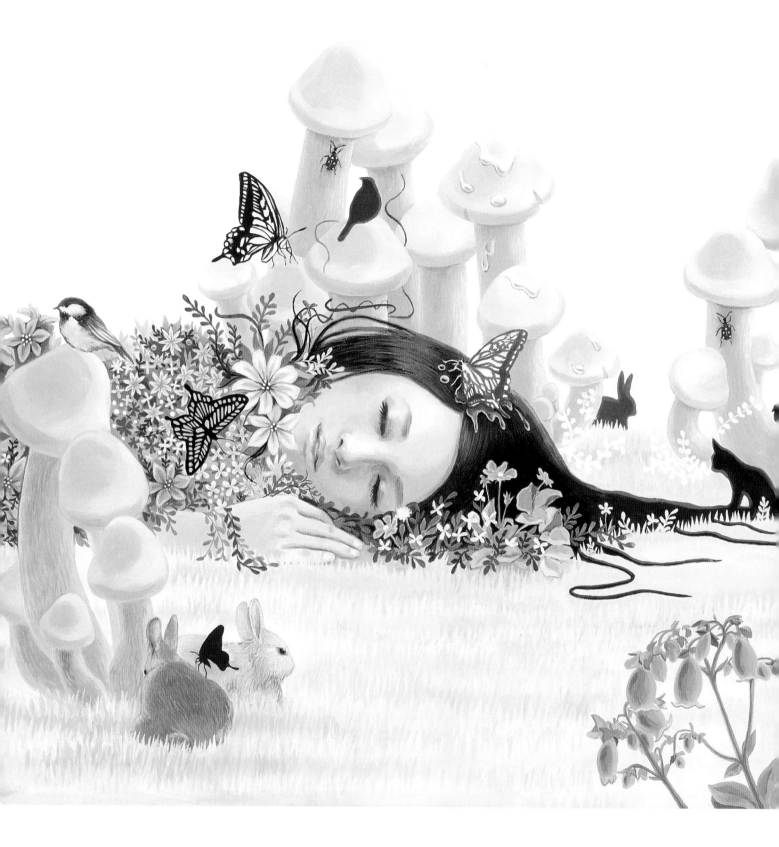

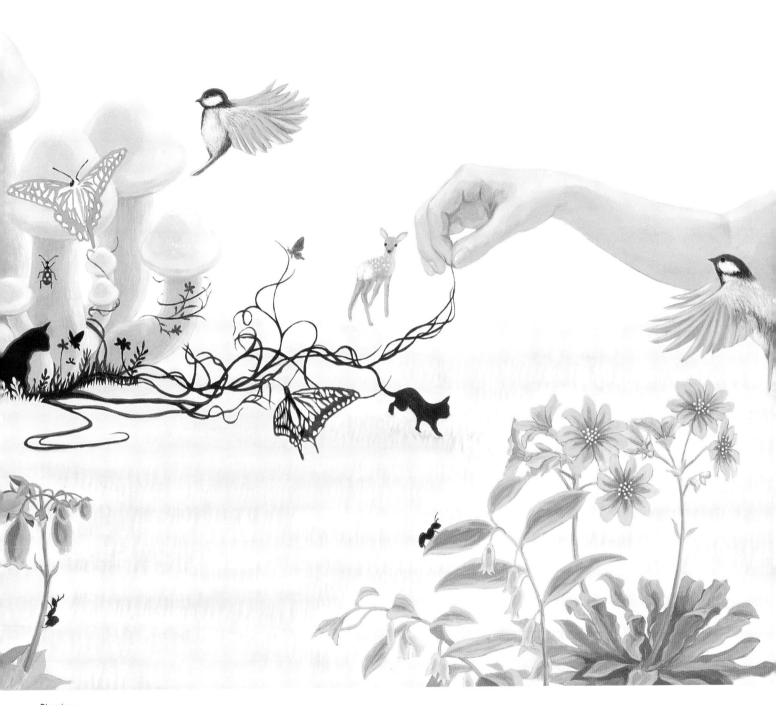

Blessing.
Oil on canvas.

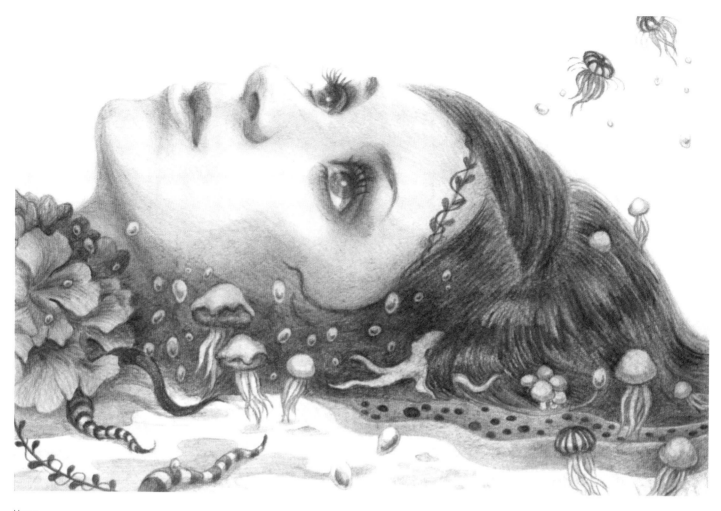

Hope.
Pencil on paper.

From top: p_15
Polka dot.
Acrylic on canvas.

Borderline.
Acrylic on canvas.

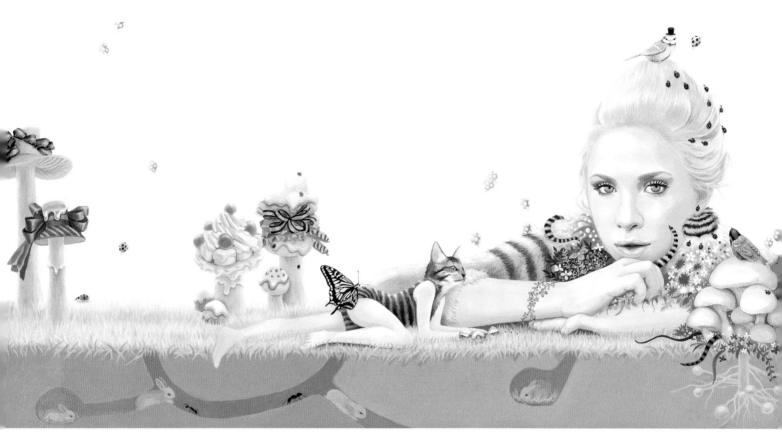

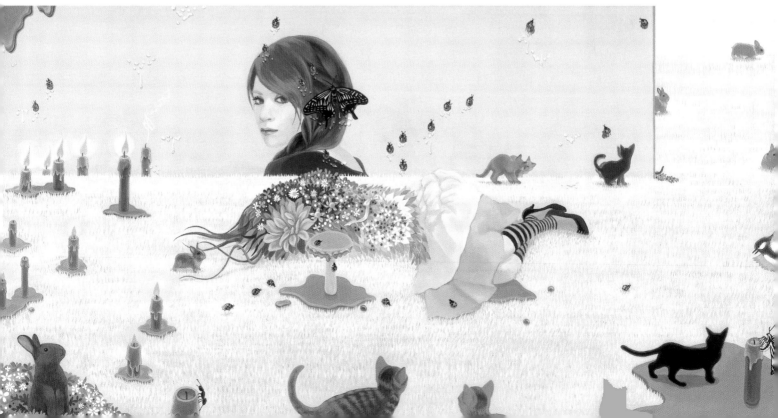

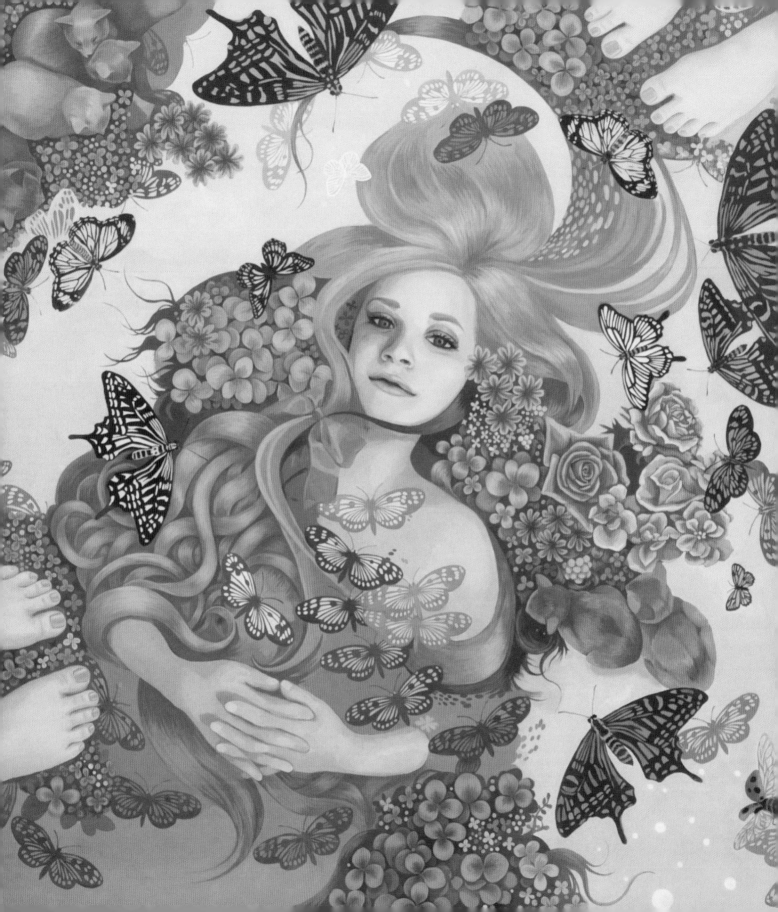

Rabbit hole.
Oil on canvas.

p_16
Vortex.
Oil on canvas.

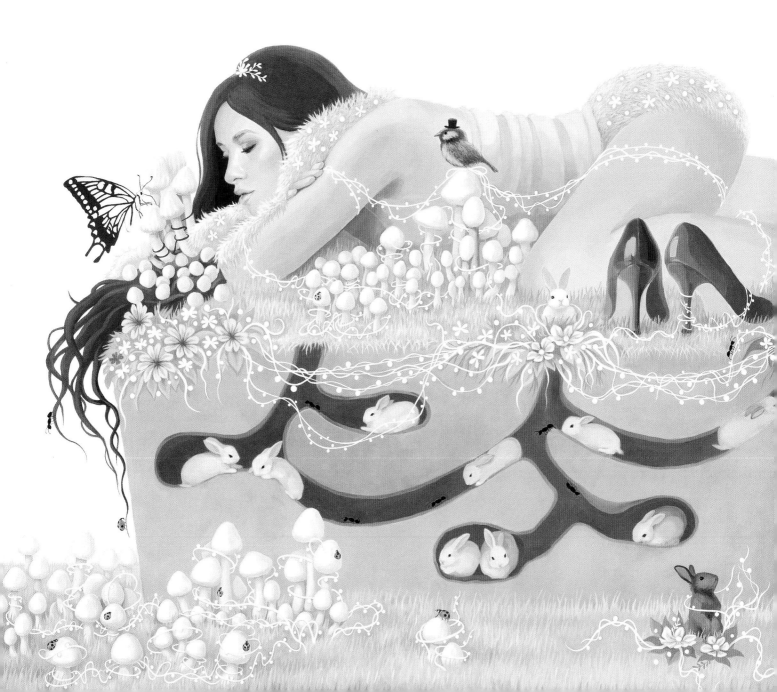

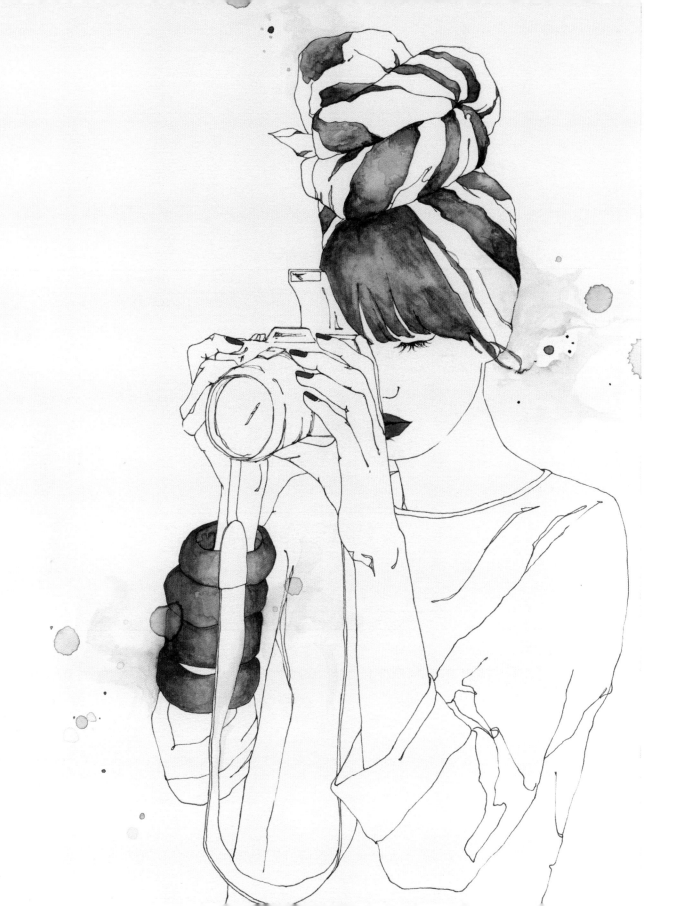

Emma Leonard

visit: http://bonesbraidsandatricycle.blogspot.com

I am an illustrator based in Melbourne, Australia and I create soft, delicately rendered images of women.
I attempt to infuse my work with an impression of fragility and melancholy, to capture a sense of ethereal beauty and femininity.

I work primarily in transparent media, usually pencil and watercolour, but I also enjoy experimenting with pattern and collage. I love combining the control and purpose of my line work with the spontanaeity and movement of colour. I am influenced by geometric shapes and recurring patterns, mid-century fashion illustration and natural history museums.

Soy una ilustradora que vive en Melbourne, Australia. Creo imágenes de mujeres difuminadas y plasmadas con delicadeza.
Intento que mi obra se inspire en una impresión de fragilidad y melancolía para capturar un sentido de belleza etérea y de feminidad.

Trabajo fundamentalmente con materiales transparentes, normalmente lápiz y acuarela, aunque también disfruto experimentando con el estampado y el collage. Me encanta combinar el control y el propósito de mi línea de trabajo con la espontaneidad y el movimiento de color. Estoy influenciada por las formas geométricas y los estampados repetitivos, la ilustración de mediados del siglo XX y los museos de historia natural.

p_18
About A Girl.
Ink and watercolor.

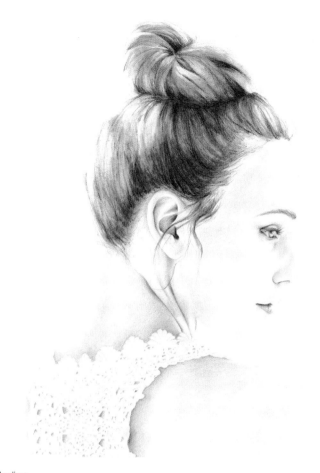

Indigo.
Pencil.

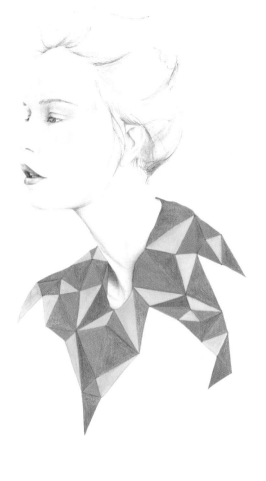

Harlequin 1.
Pencil and
watercolor.

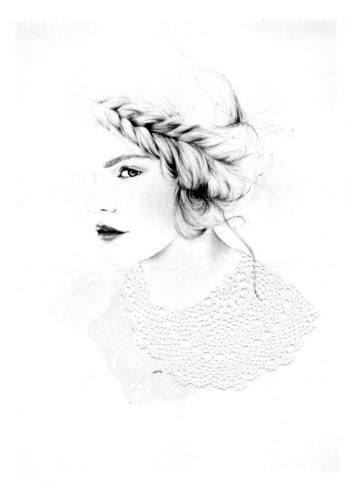

Linen & Lace.
Pencil and digital collage.

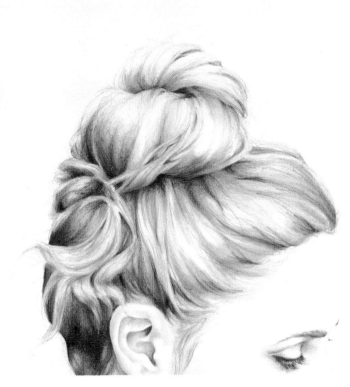

A Perfect Mess.
Pencil.

Girl Reading.
Ink and watercolor.

p_23
Tender To The Blues.
Ink and watercolor.

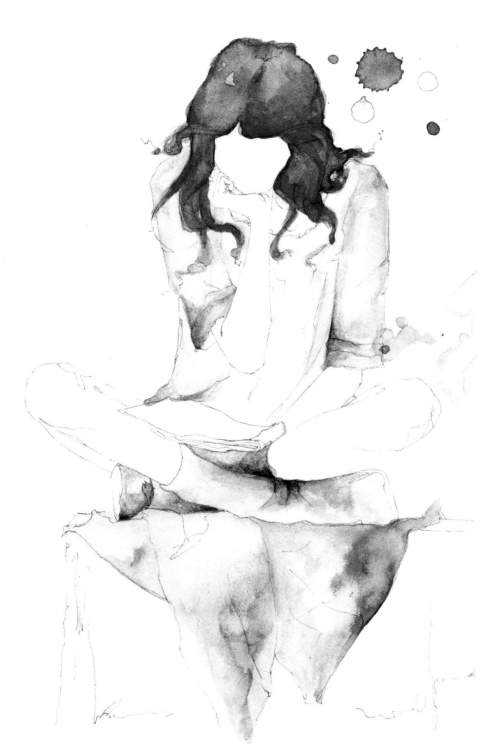

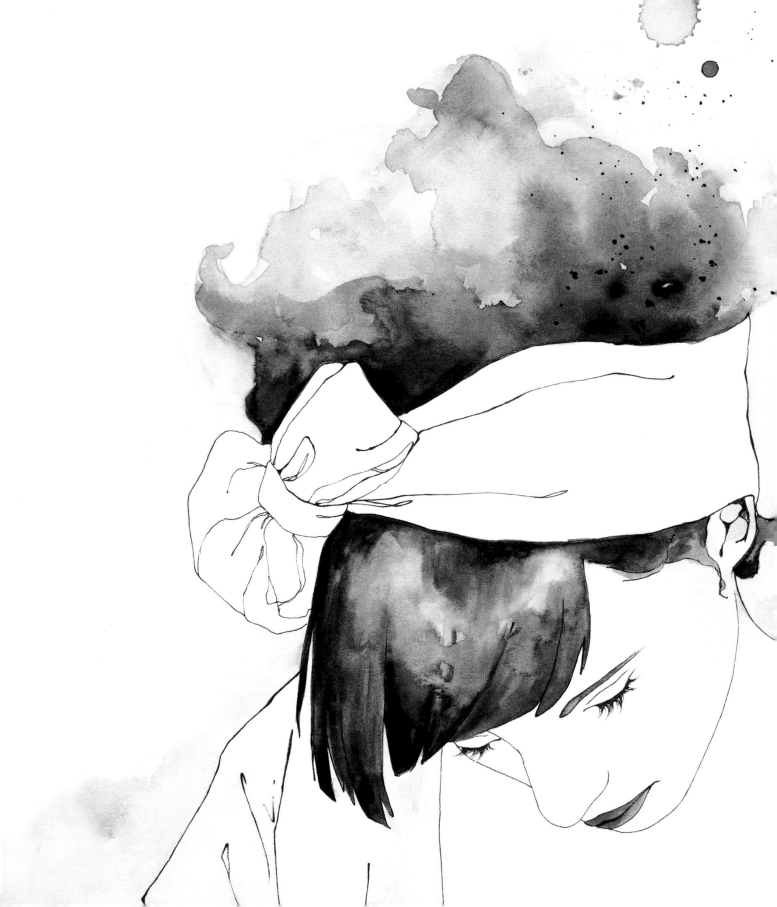

Yosuke-Ueno

visit: www.spaceegg77.com

I am an artist that lives in Tokyo. I have been taking part in shows in the US, Europe and Asia. The important thing I always consider when create is, to tie up pop surrealism and Japanese traditional painting.

I usually use acrylic colors on canvas. Japanese traditional temples inspire me to create. Though my pieces aren't seen to represent Japanese traditional things directly at first sight, my art works derive from these things in some way such as the poses and positions of characters.

Soy un artista que vive en Tokio. He participado en exposiciones en los Estados Unidos, Europa y Asia. Lo que siempre he creído que es importante a la hora de crear es mezclar el surrealismo pop con la pintura tradicional japonesa.

Normalmente utilizo colores acrílicos sobre el lienzo. Los templos tradicionales japoneses me inspiran para crear. Aunque mis piezas no están consideradas para representar directamente y a primera vista lo tradicionalmente japonés, mis obras de arte se basan en ello de alguna manera, como las poses o las posiciones de los personajes.

p_24
N.N.A.
Acrylic on canvas.

Life With River.
Acrylic on canvas.

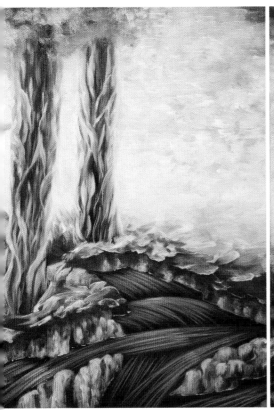
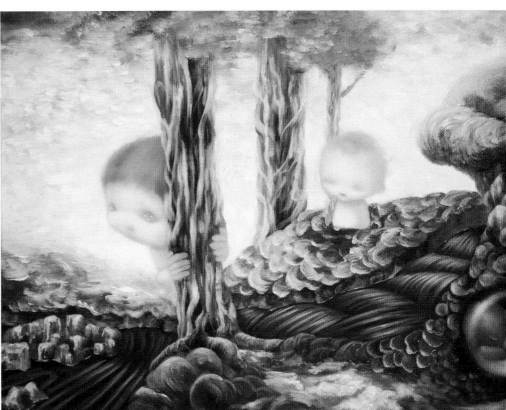

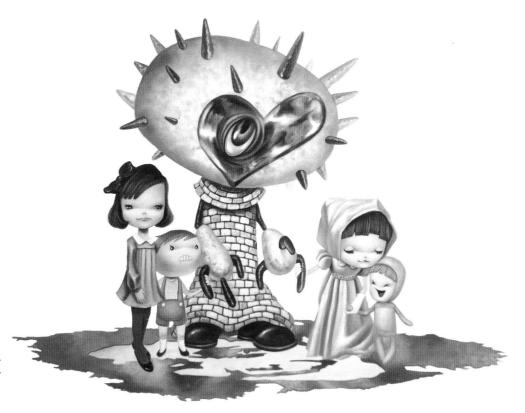

Inosent and Something.
Acrylic on canvas.

Life Tree Panorama - The Resurrection.
Acrylic on canvas.

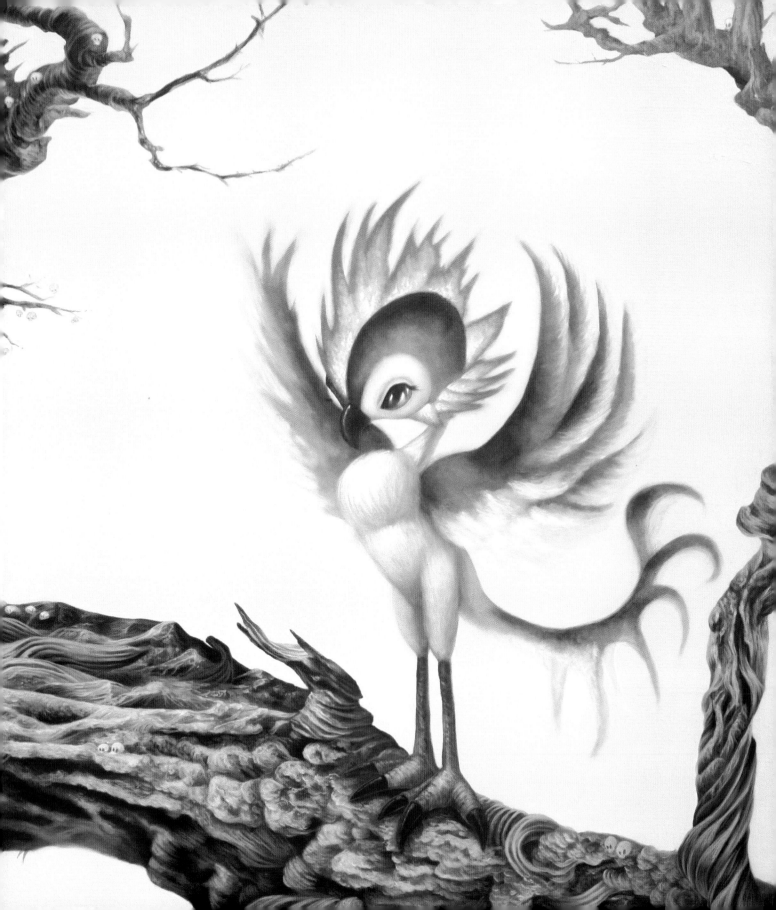

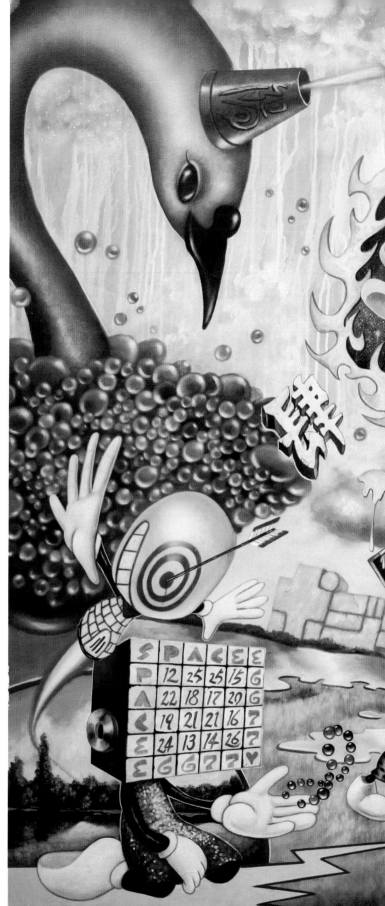

Positive-E. no. 4.
Acrylic on canvas.

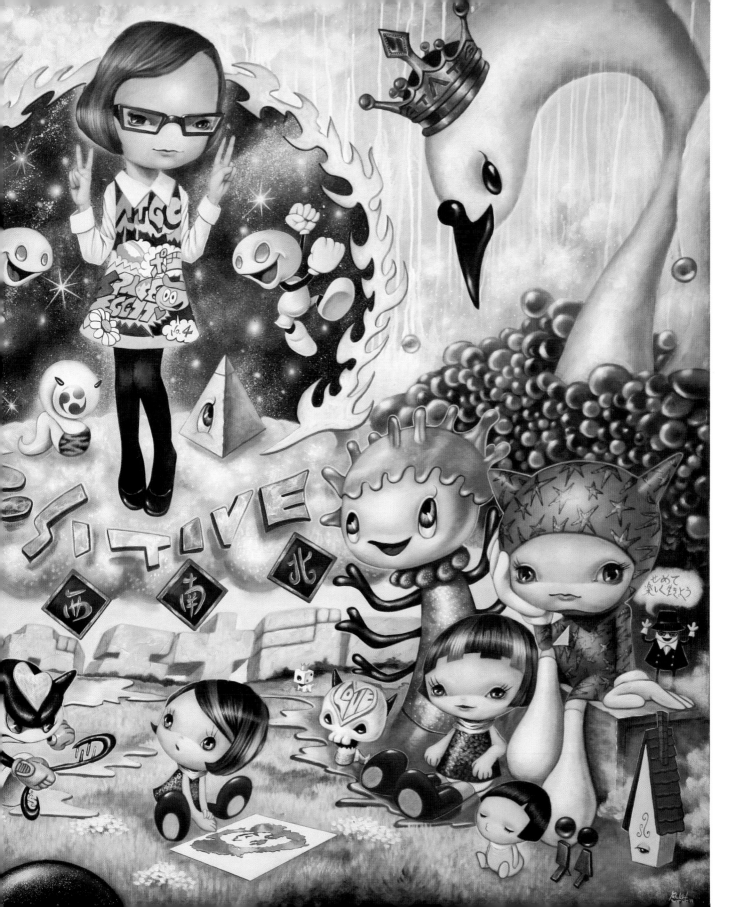

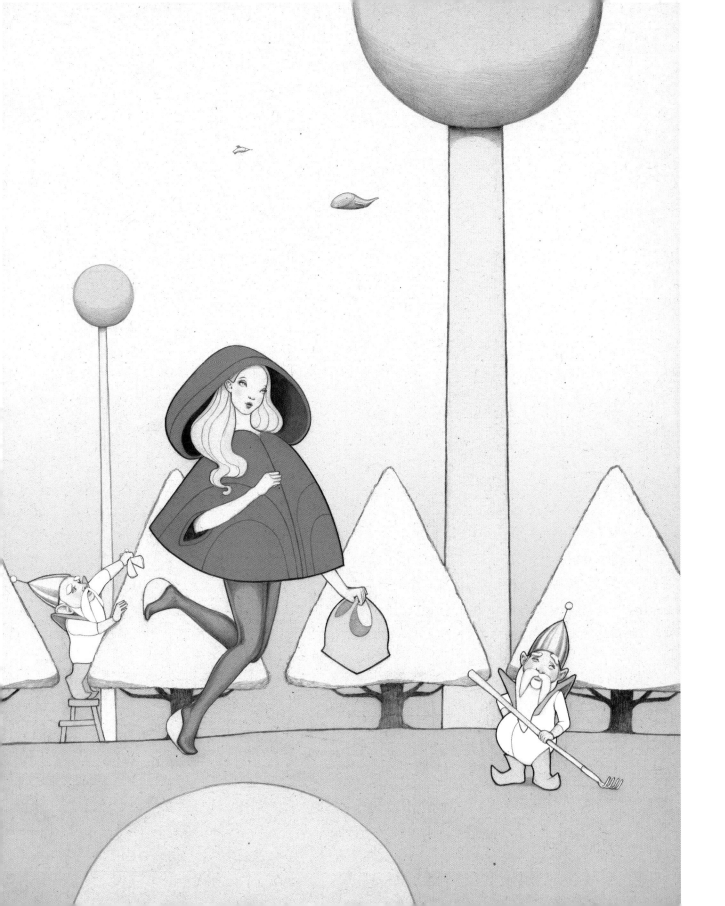

Denise Van Leeuwen

visit: http://denisevanleeuwen.com

Authenticity is very important to me when I create an illustration. I like to see in a drawing that it is handmade and try to balance the colors. Graphite pencils are my favourite. Sharp points make me able to put almost photo-realism in the details, and on the other hand leave air and space and cleanness to an illustration.

Beauty and a little humour characterizes my work. I work for fashion magazines and have created my first children's book in 2010. That whole new experience made me even more creative I think. Drawing for children challenges your imagination.
I discovered the perfect paper about six years ago, and have been drawing on it ever since. It's called CANSON Papier Recyclé. It is very smooth and has a nostalgic, recycled feel. I could not do without it. Too bad they stopped producing it. Please contact me if you find it somewhere and get a free drawing in return. info@denisevanleeuwen.com. Thank you!

Para mí, la autenticidad es muy importante a la hora de crear una ilustración. En un dibujo, me gusta ver que se ha hecho a mano y que trata de equilibrar los colores. Los lápices de grafito son mis favoritos. Los puntos nítidos me permiten llegar casi al fotorrealismo en los detalles y por otro lado, dejar aire, espacio y pureza en la ilustración.

Mi obra se caracteriza por la belleza y por un poco de humor. Trabajo para revistas de moda y he creado mi primer libro infantil en el 2010. Creo que toda esa nueva experiencia me ha hecho aún más creativa. Dibujar para niños desafía tu imaginación.
Descubrí el papel perfecto hace aproximadamente seis años y he dibujado en él desde entonces. Se llama CANSON Papier Recyclé, es muy suave y transmite una sensación de nostalgia y reciclado, no podría hacerlo sin él, es una lástima que hayan dejado de producirlo. Si lo encuentran en algún sitio, por favor, contacten conmigo y a cambio, tendrán un dibujo gratis. info@denisevanleeuwen.com. Gracias!

p_32
Fairytale Planet.
Pencil on paper, digital colouring.

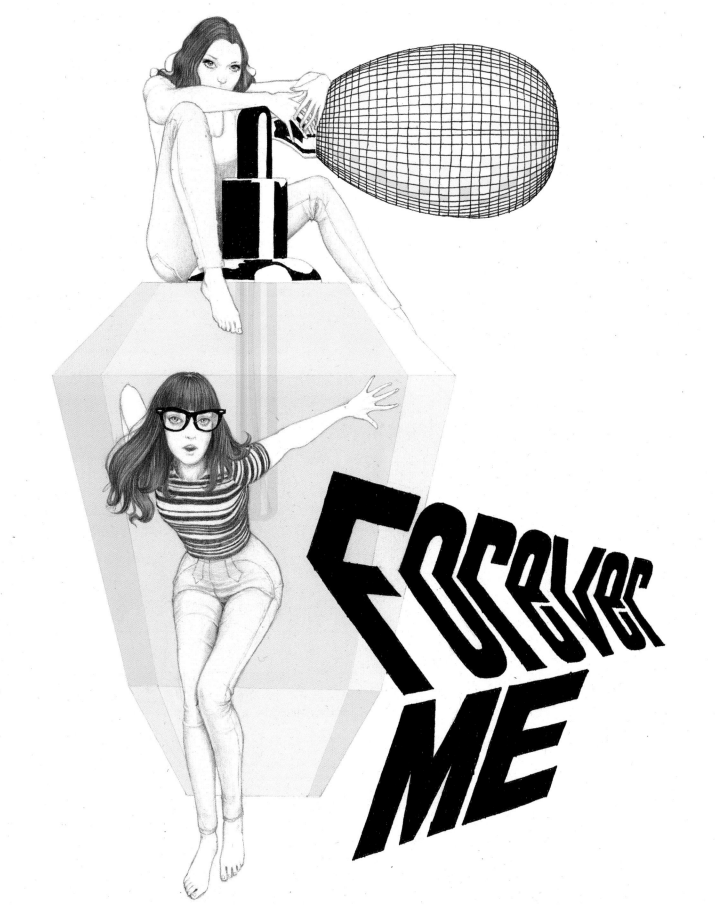

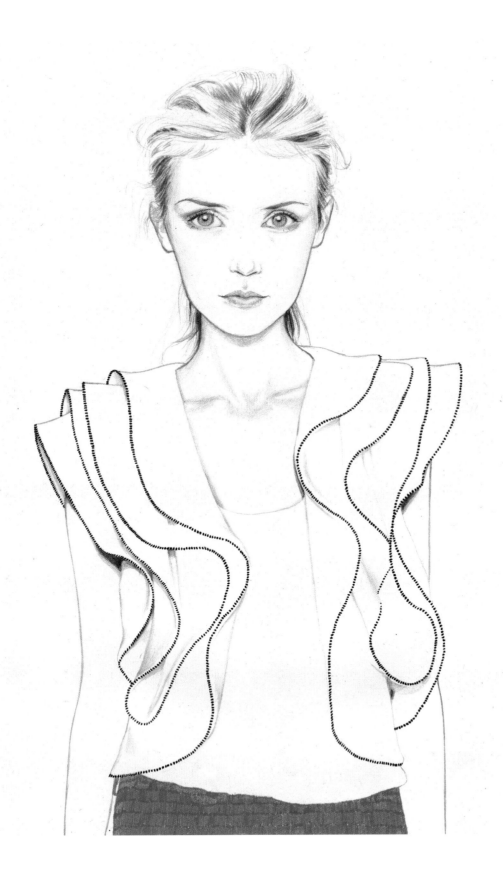

Carlos Miele.
Pen and pencil on
paper, digital colouring.

p_34
Forever Me.
Pen and pencil on
paper, digital colouring.

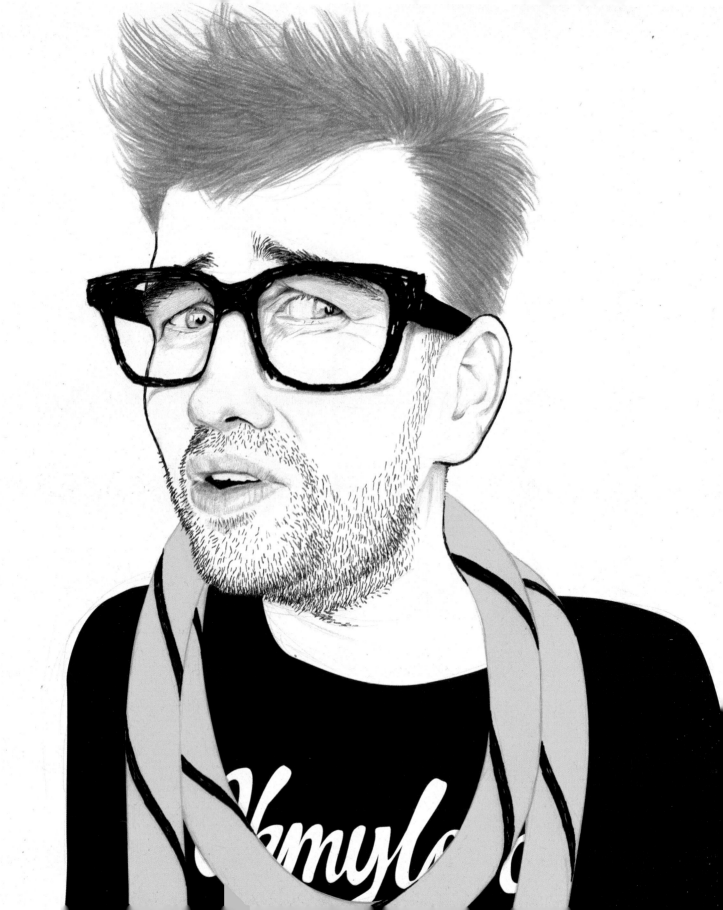

Leg er maar een knoopje in

Vasectomy.
Pen and pencil on paper, digital colouring.

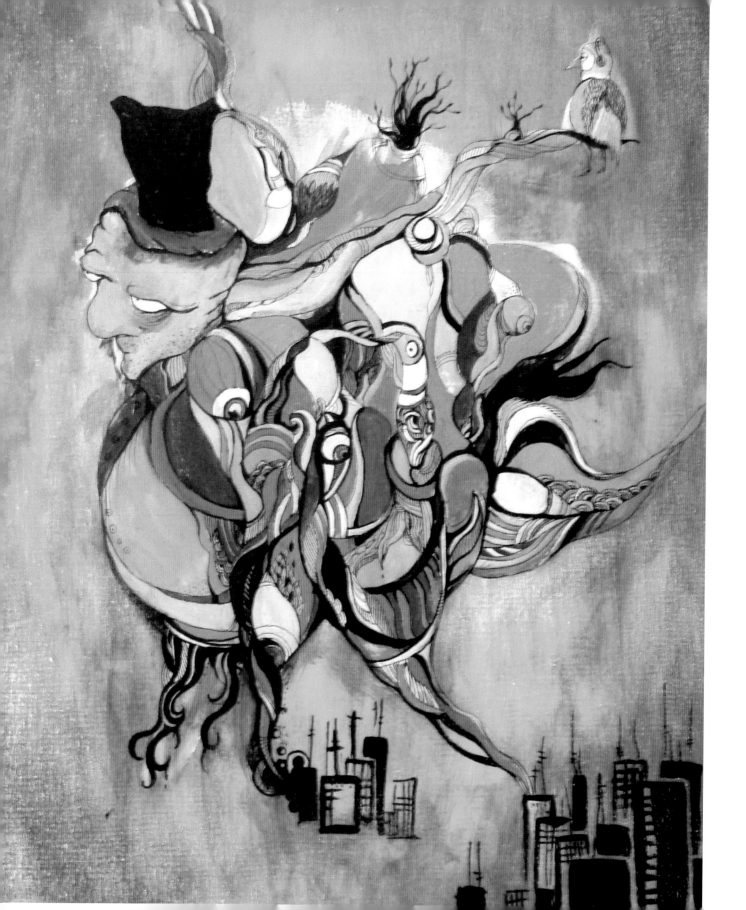

visit: www.sirmano.com.au

Well Sirmano is my little alter ego, I like to think of him as taking over my creative mind side and splatting it onto paper. I like to take reality and place a completely different interpretation of it onto paper with little energy bits here and there.

Pen + Paper… is where I usually start, then it moves to walls, paints and textures and where I finish i'm never really sure. I very much like to move, rotate and explore this lovely world we have, so currently living in Barcelona has given me never ending visuals and inspiration for my sirmano to run free… I'm inspired by everyday funny or make-believe experiences, and well, people around me usually give me loads of that and it's usually the fuel I need to create.

Bueno, Sirmano es mi pequeño otro yo. Me gusta pensar que se apodera de mi parte mental creativa y la estampa sobre el papel. Me gusta tomar la realidad y plasmar una interpretación completamente diferente de ella en el folio con pedacitos de energía por aquí y por allá.

Bolígrafo + papel… normalmente es por donde empiezo y luego, se traslada a murales, pinturas y texturas; nunca estoy muy segura de donde acabará. Me gusta mucho moverme, dar vueltas y explorar este maravilloso mundo que tenemos, así que, el vivir actualmente en Barcelona me ha proporcionado infinitas imágenes e inspiración para que mi Sirmano fluya libremente… Me inspiran las diversiones de cada día o las experiencias fantasiosas, y bueno, la gente que me rodea me suele dar mucho de eso y por lo general, es el combustible que necesito para crear.

p_38
Some where.
Pen, acrylic on canvas.

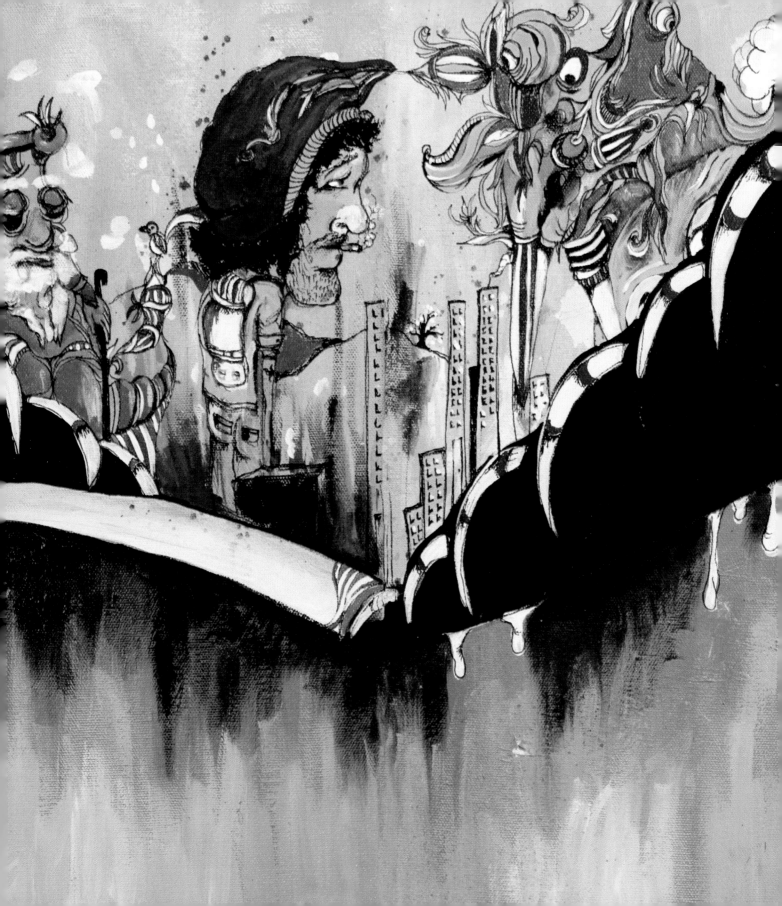

Elasto.
Pen, acrylic on canvas.

p_40
Carnie.
Pen, acrylic on canvas.

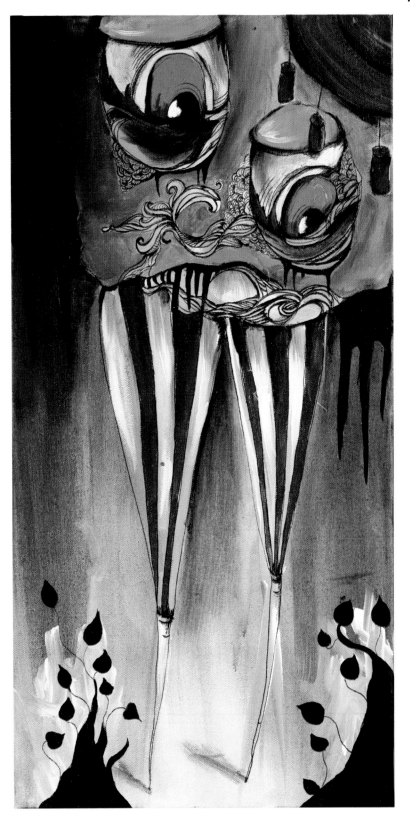

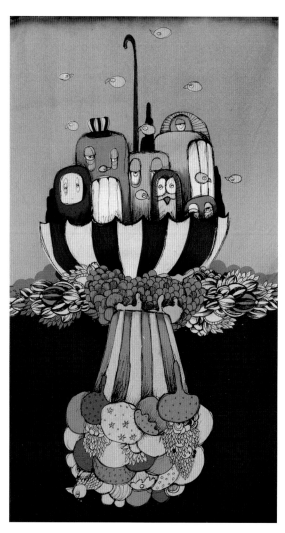

Shelly.
Pen, acrylic digital colour.

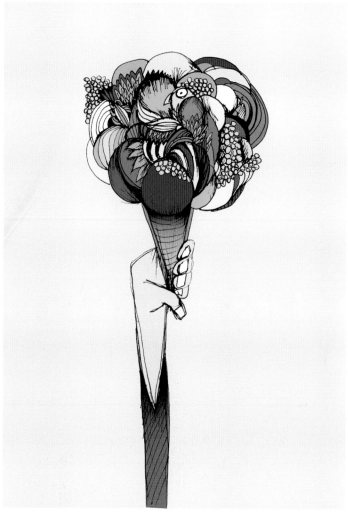

Freddy too tall.
Pen, paper and digital colour.

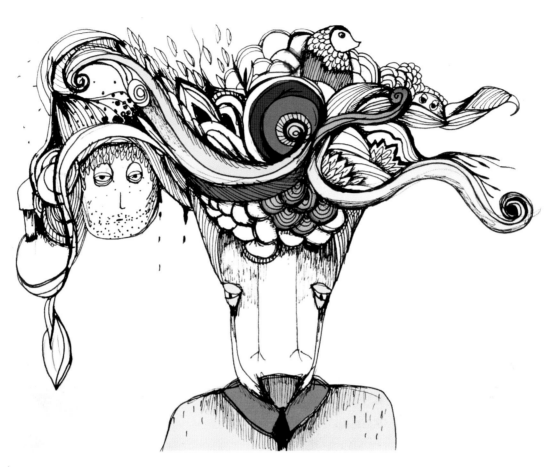

Un alce en un traje.
Pen, paper and digital colour.

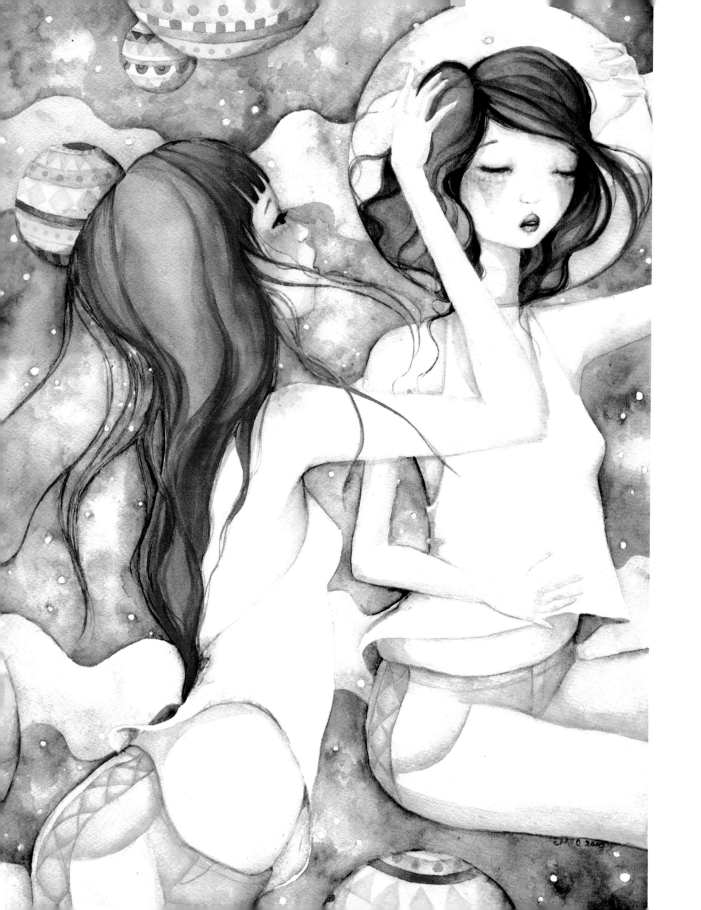

Melissa Contreras

visit: www.axelhoney.com

I do my best to live my life in the moment. Enjoy the act of simply breathing. In trying to figure out my reason for being, I've decided I'll probably never find out but it is probably a good idea to just make the most of the time I have here in this world. I feel the best gift I have to give is my art.

There is an undercurrening theme of feminism in a lot of my work, about being a women. It's also about celebrating imagination. The power to believe that anything is possible as long as you can dream it. You can draw anything, ANYTHING. There are no limits. I start all my pieces by doodling in my sketchbook. I'll have a general theme or subject matter in my head that I work out up there first and then try and translate on the paper. My favorite tool is a 0.5 2B lead mechanical pencil and a gum eraser. I then enlarge it to paint. Sometimes freehand or sometimes I'll use an enlarger to get the balance and composition to mirror my initial sketch. After it is pencilled, I usually work in gouache to add color and shading.

Hago todo lo posible para vivir el momento. Disfrutar el hecho de simplemente respirar. Al intentar descubrir la razón de mi existencia, he decidido que, seguramente, nunca la descubra, pero quizás sea una buena idea aprovechar el mayor tiempo que tenga en este mundo. Siento que el mejor regalo que tengo para dar es mi arte.

Existe un tema de trasfondo feminista en muchos de mis trabajos, sobre el ser mujer. También trata sobre celebrar la imaginación, el poder de creer que cualquier cosa es posible, siempre y cuando puedas soñarlo, puedes dibujar cualquier cosa, CUALQUIERA, no hay límites. Empiezo todas mis obras garabateando en mi cuaderno de bocetos. Tengo una idea o tema general en mi cabeza que, primero, surge y luego, pruebo y traduzco en el papel. Mis herramientas favoritas son un portaminas de 0.5 2B y una goma de borrar, después, lo agrando en la pintura, unas veces a mano alzada y otras utilizo una ampliadora para conseguir el equilibrio y la composición y reflejar mi boceto inicial. Tras hacer el esbozo, suelo pintar al gouache para colorear y sombrear.

p_44
Limbo.
Gouache on watercolor paper.

p_46-47
The Letter.
Gouache on watercolor paper.

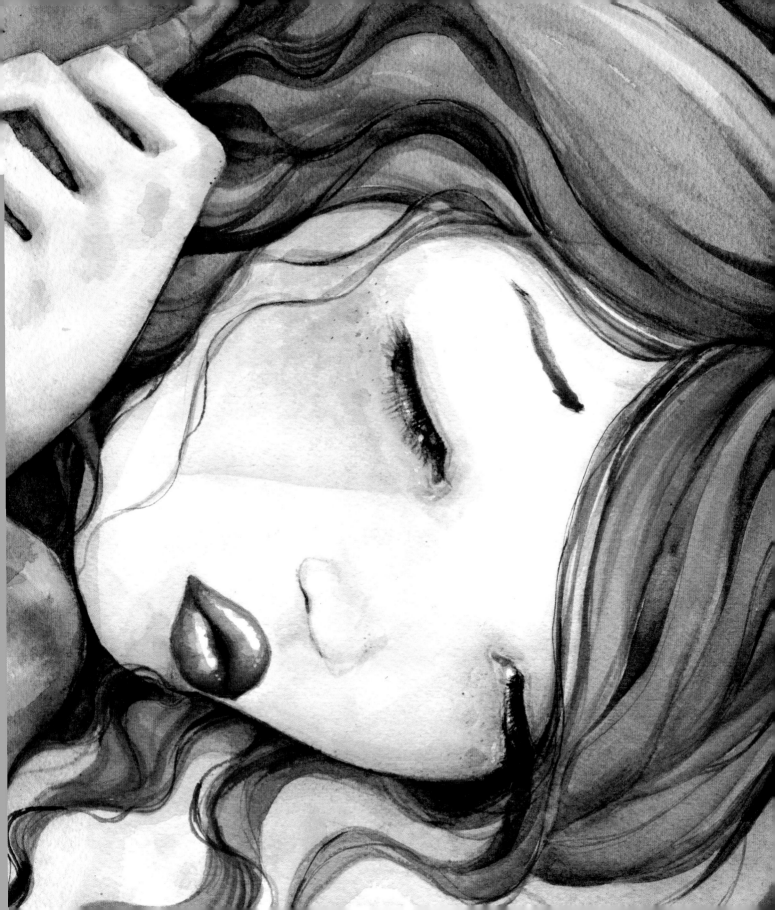

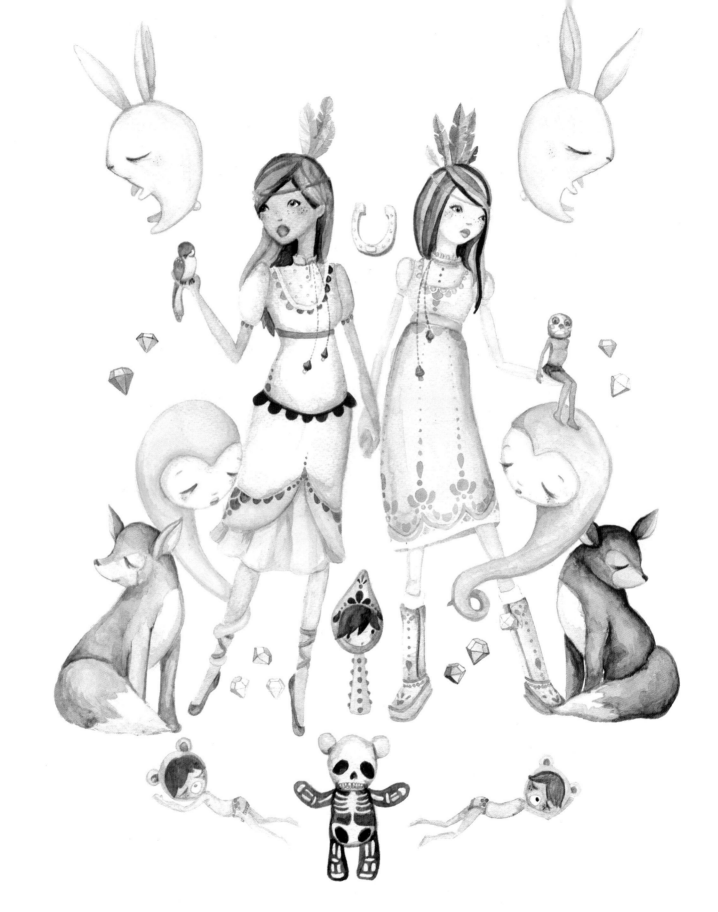

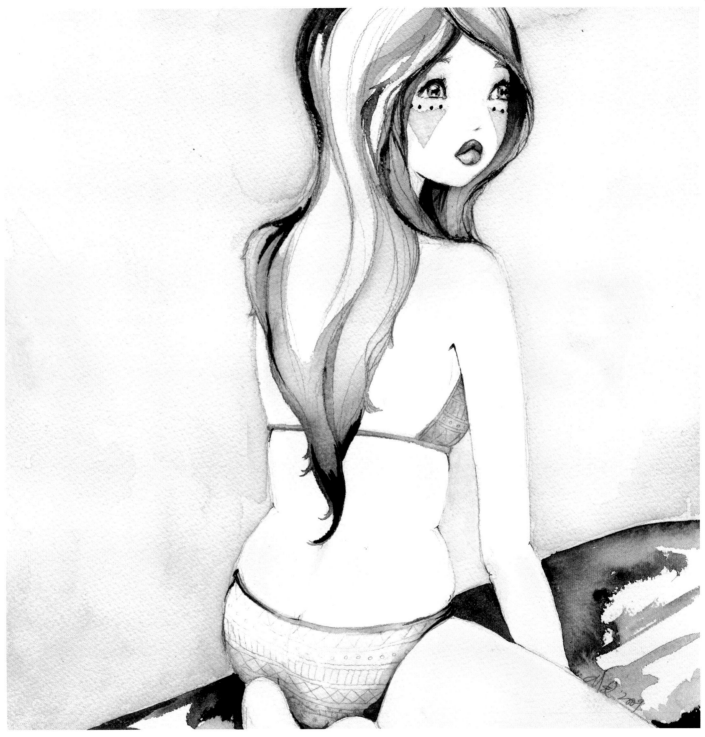

Tide.
Gouache on watercolor paper.

p_48
Alex Honey.
Gouache on watercolor paper

p_50-51
Transit.
Gouache on watercolor paper.

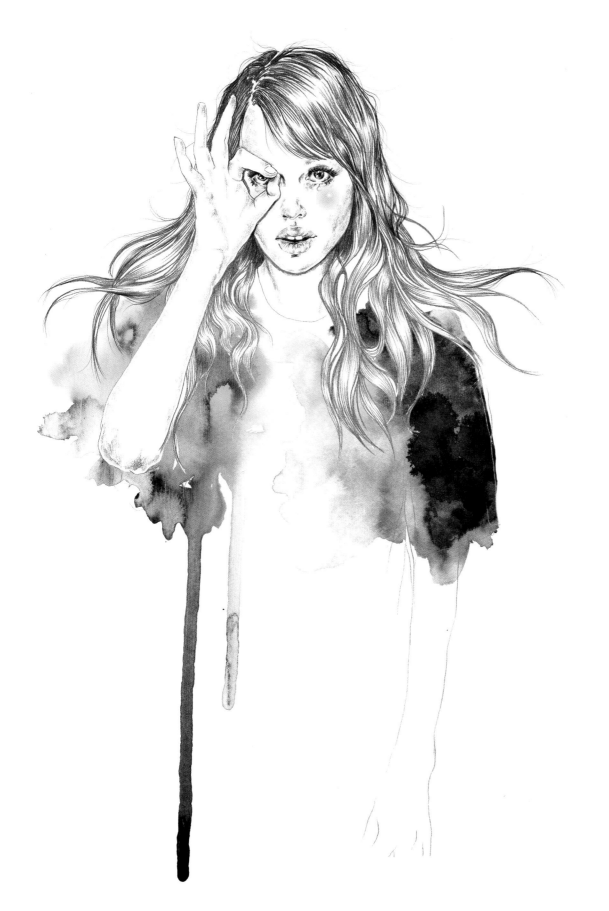

Esra Roise

visit: www.esraroise.com

I'm a Norwegian illustrator working and living in Oslo, Norway. I have been drawing for as long as I can remember, and I'm a recent graduate from the Acedemy of The Arts here in Oslo. I work as a freelance illustrator, doing mainly fashion orientated work, which I absolutely love.

I guess you could say that I in many ways can be defined as a very classical illustrator, as my primary tools are the traditional pencil and watercolor, but I often do final editing in Photoshop.
I am very much inspired by pop-cultural phenomenons as well as small unimportant everyday situations, people, snapshot photography, the fashion industry,the internet, music, awkward moment and imperfections.
My artwork is often a hybrid between photography and imagination, and I strive to maintain a feeling of "life" in my drawings, as opposed to the static, if that makes any sense.
Clients include: Vogue, Stylesight, NYLON, Wallpaper*, LEVI'S and VICE to name a few.

Soy una ilustradora noruega que trabaja y vive en Oslo, Noruega. Dibujo desde que tengo uso de razón y acabo de terminar la carrera en la Academia de las Artes, en Oslo. Soy ilustradora autónoma y mi trabajo principalmente, está relacionado con la moda, lo cual me fascina.

Supongo que podría decir que se me puede definir, en muchos sentidos, como una ilustradora muy clásica, ya que mis herramientas fundamentales son el lápiz tradicional y la acuarela, pero a menudo utilizo Photoshop para la edición final.
Me inspiran mucho los fenómenos de cultura pop, así como las pequeñas situaciones sin importancia de cada día, la gente, las fotografías, la industria de moda, Internet, la música, los momentos delicados y las imperfecciones.
Mis obras son normalmente, un híbrido entre la fotografía y la imaginación, y me esfuerzo por mantener una sensación de «vida» en mis dibujos, como oposición a la estática, si es que eso tiene algún sentido.
Clientes: Vogue, Stylesight, NYLON, Wallpaper*, LEVI'S y VICE, por nombrar algunos.

p_52
Hello.
Pencil, watercolor.

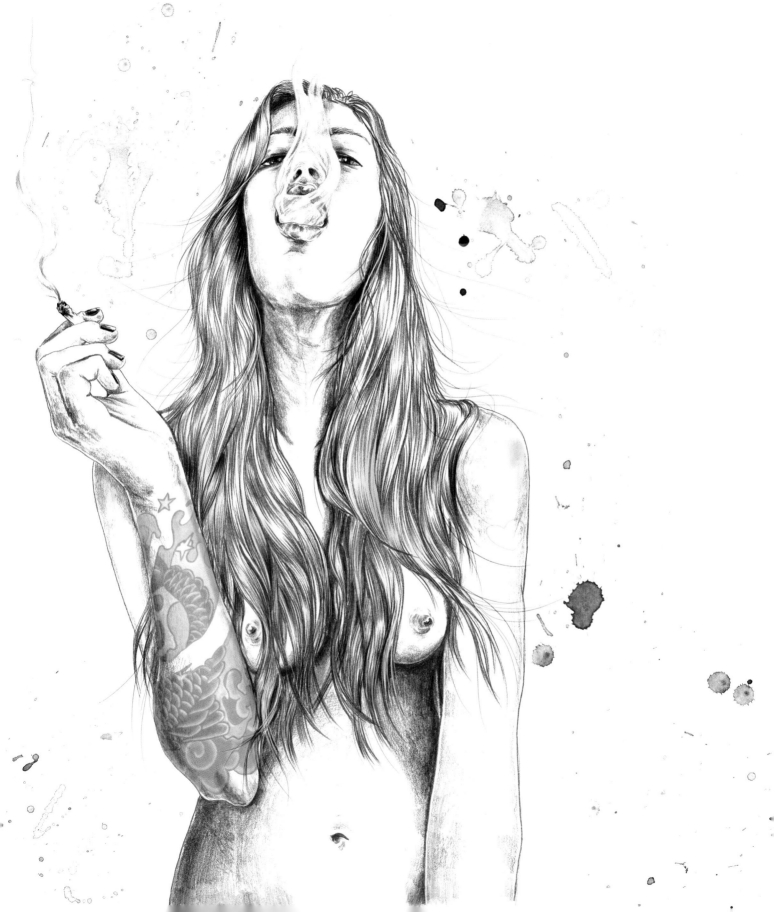

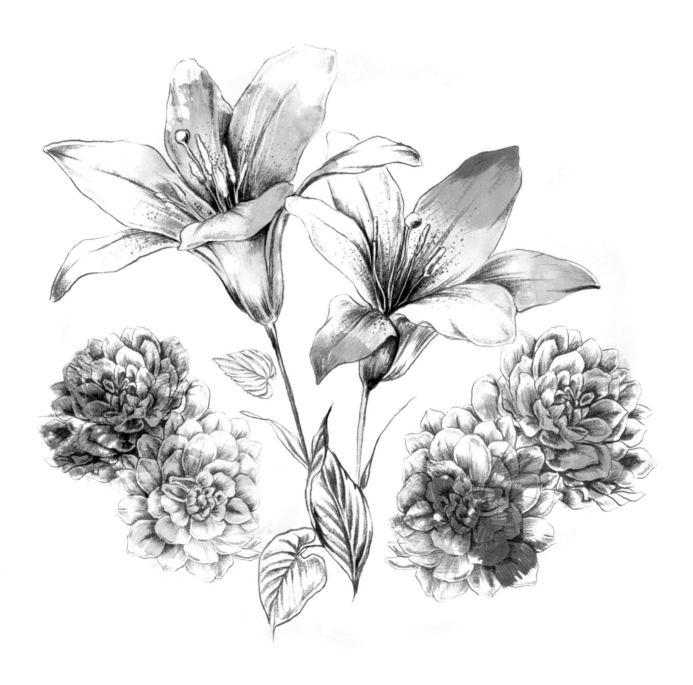

Vogue Floral.
Pencil, watercolor, ink. (Vogue China).

p_54
Scream For Icecream.
Pencil, watercolor.

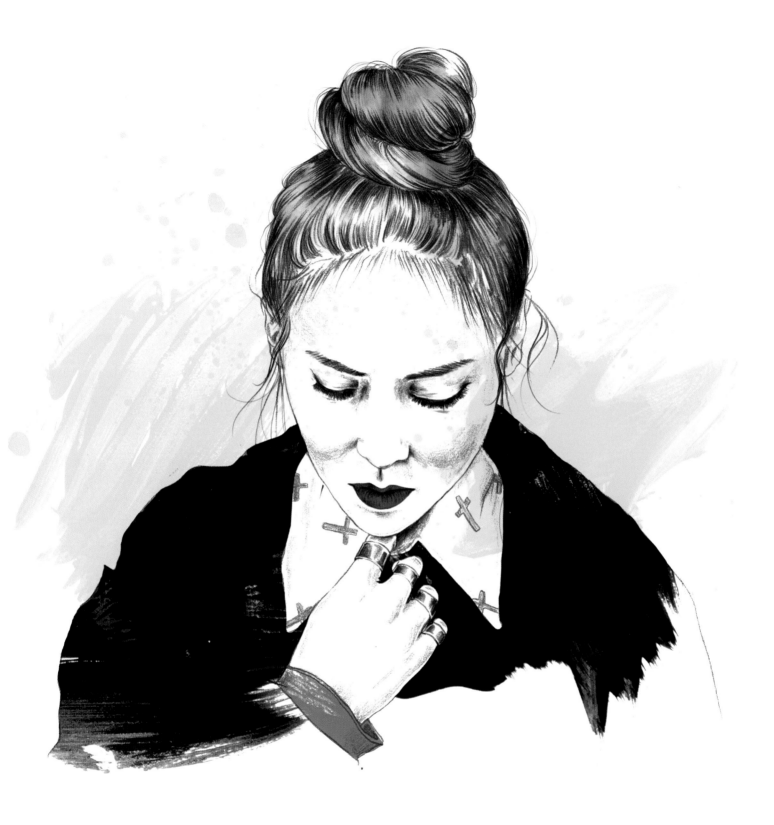

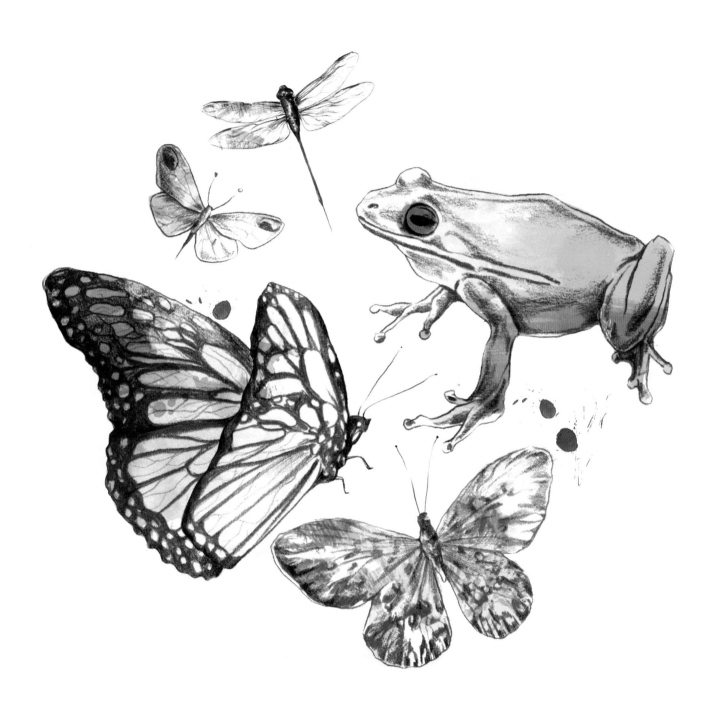

Vogue Animals.
Pencil, watercolor, ink. (Vogue China).

p_56
Stop it.
Pencil, watercolor.

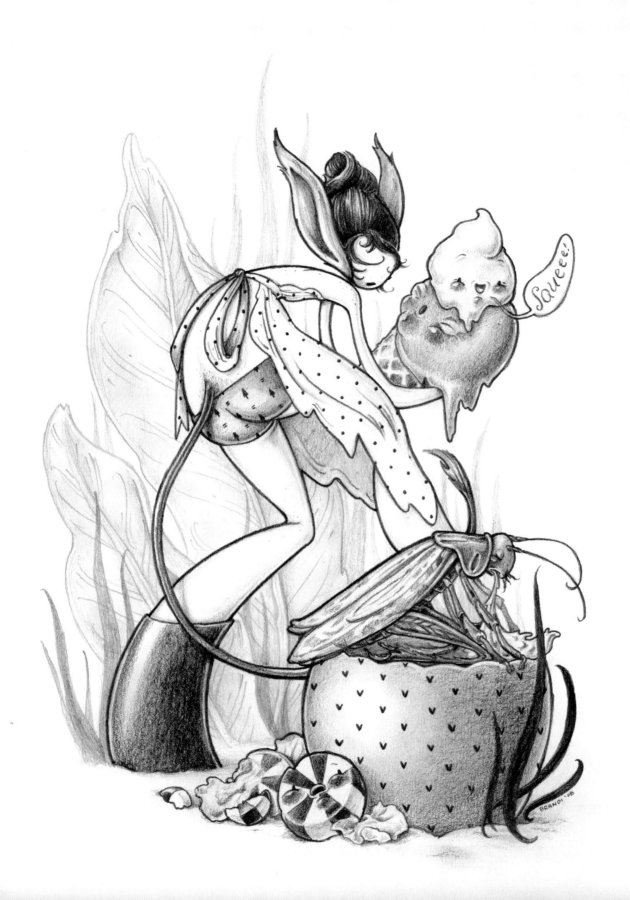

Brandi Milne

visit: www.brandimilne.com

My technique is just do what comes natural. I'm a self-taught artist, so if there's a certain look I want to achieve in a painting or illustration, I just mess around until I get it! That (in a way) is what inspires me to keep going - to do better each time.

I love the process of taking the image in my head and making it come alive right in front of me. I'm addicted to it. When i work I allow myself to shut out the world completely and become 100% absorbed in what I'm doing. Music, lyrics, and far away places feed my inspired mind, on top of an initial emotion that sets the painting (or drawing) in motion.

Mi técnica consiste en la naturalidad. Soy una artista autodidacta así que, si existe una cierta imagen, quiero conseguirla en una pintura o ilustración. ¡Simplemente me entretengo hasta que la consigo! Eso, en cierto modo, es lo que me inspira a seguir, a hacerlo cada vez mejor.

Me encanta el proceso de tener la imagen en mi cabeza y hacerla realidad justo delante de mí. Soy adicta a eso. Cuando trabajo, me permito dejar fuera al mundo completamente y quedarme absorta al cien por cien con lo que estoy haciendo. La música, las letras y los lugares lejanos alimentan mi mente inspirada en una emoción inicial que pone la pintura (o el dibujo) en movimiento.

p_58
Grasshopper Puke.
Drawings is graphite on paper.

p_60-61
White Fawn Sugar Scape.
Acrylic on wood.

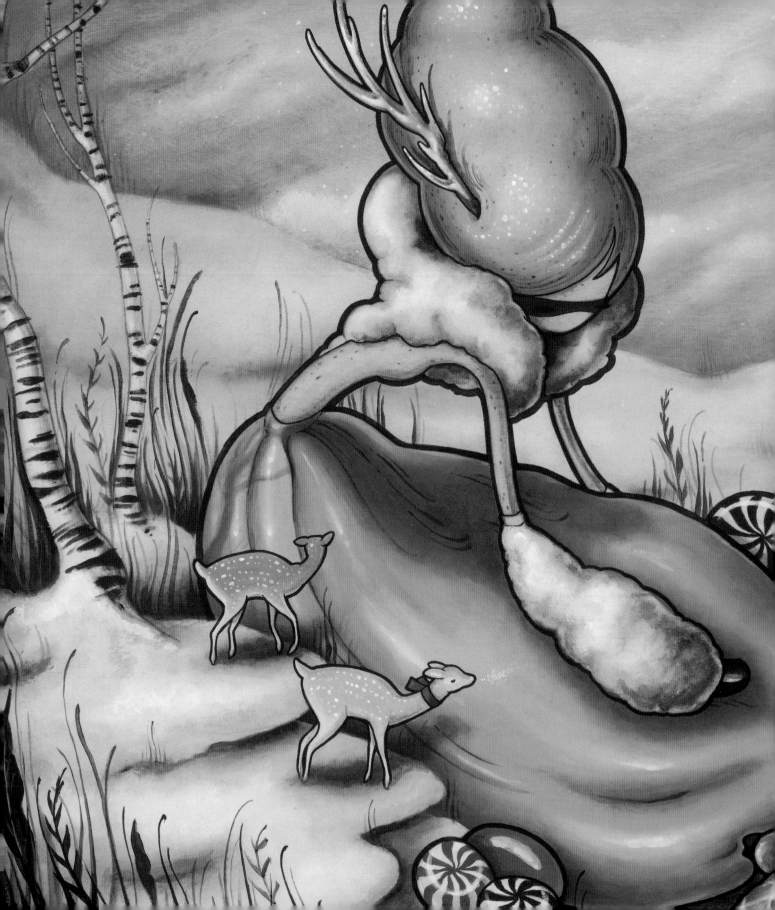

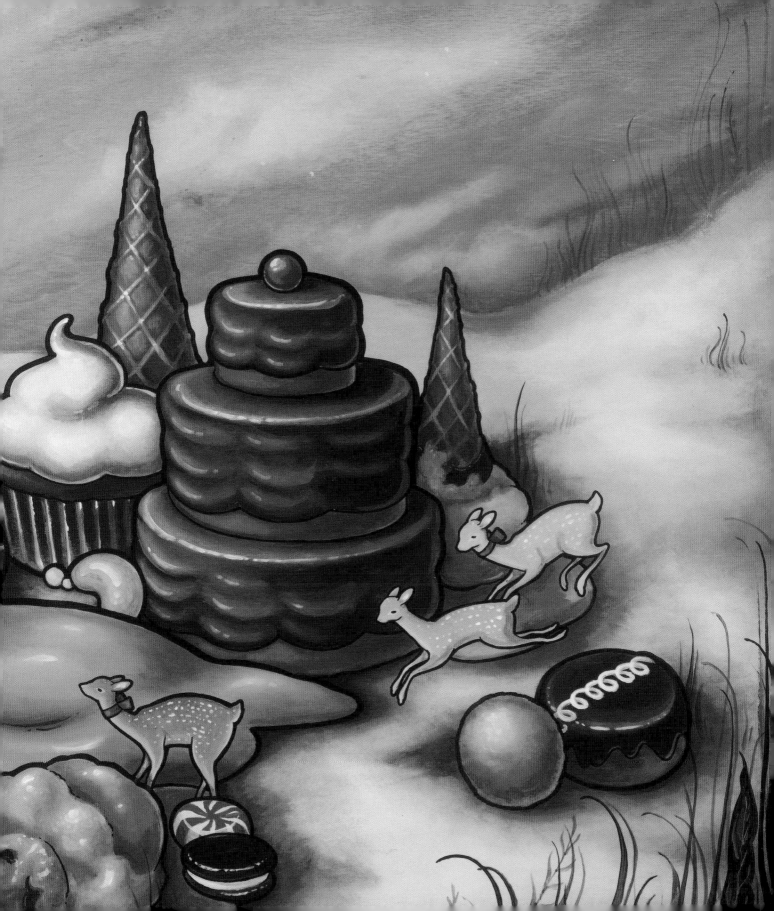

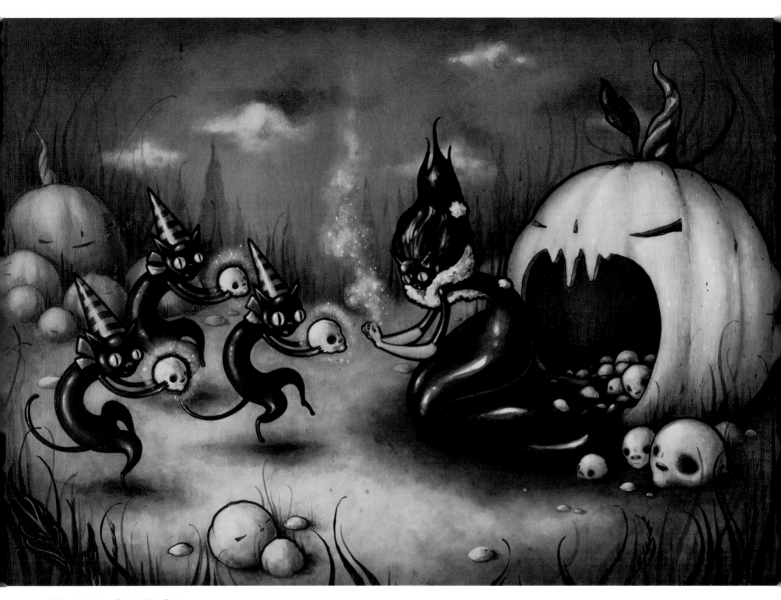

Give Me Your Soul, Little One.
Acrylic and ink on wood panel.

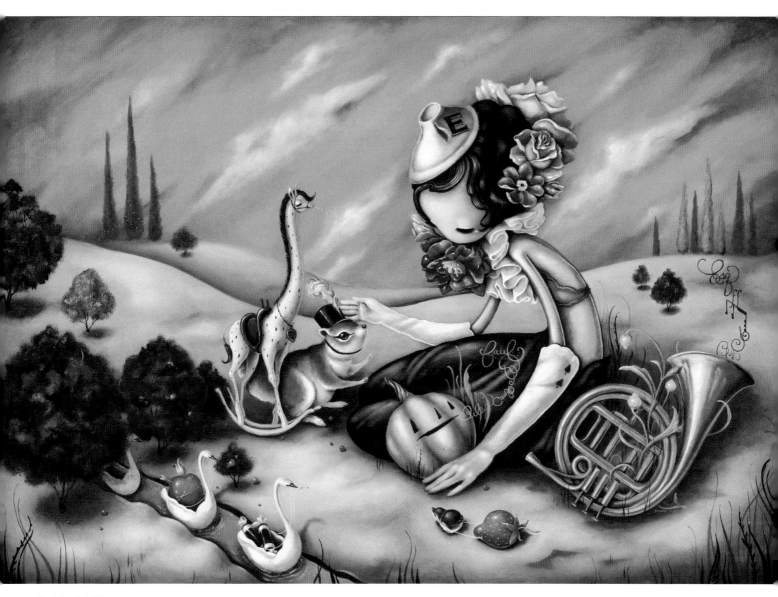

And Such is Life.
Acrylic on wood, framed.

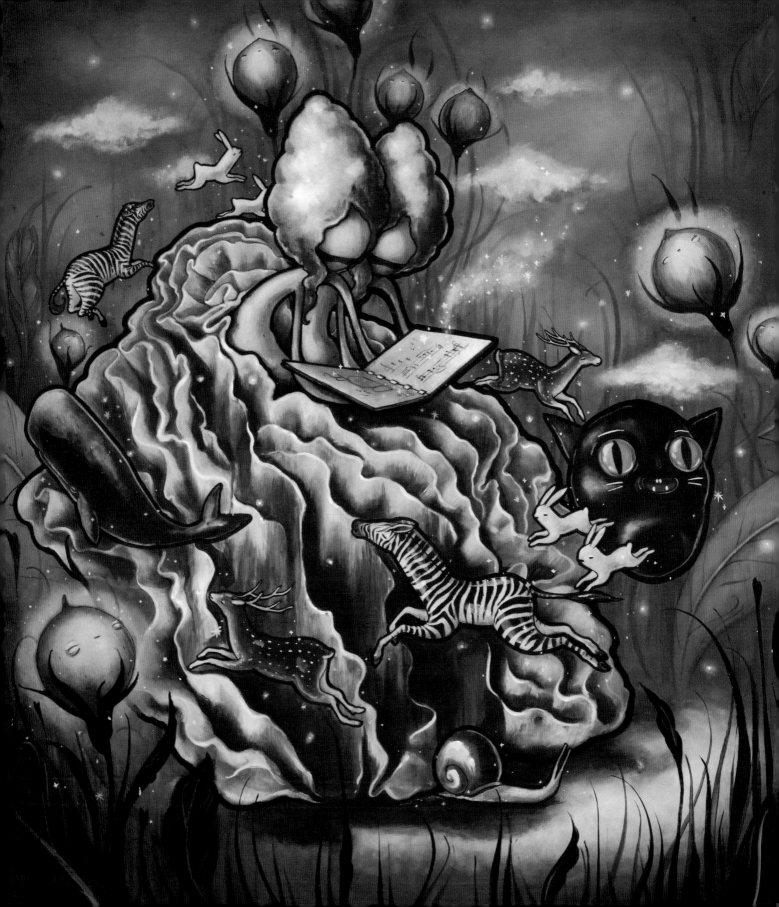

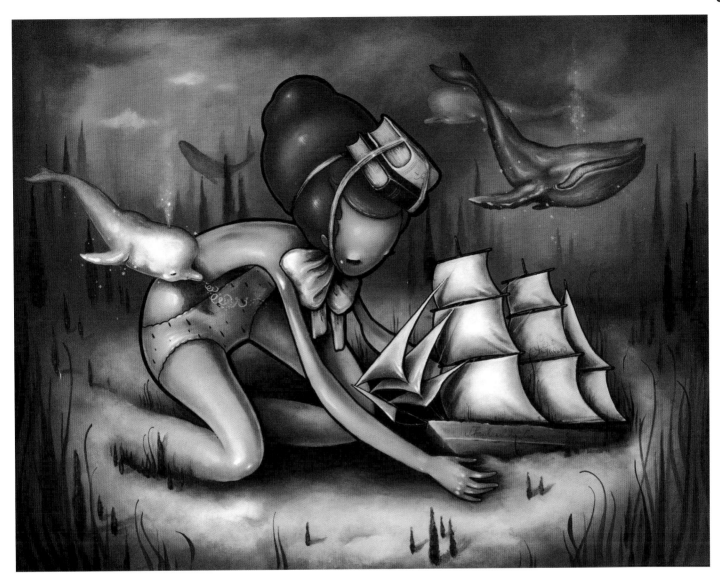

Baron of the Deep.
Acrylic on wood, framed.

p_64
The Weight.
Acrylic and ink on wood panel.

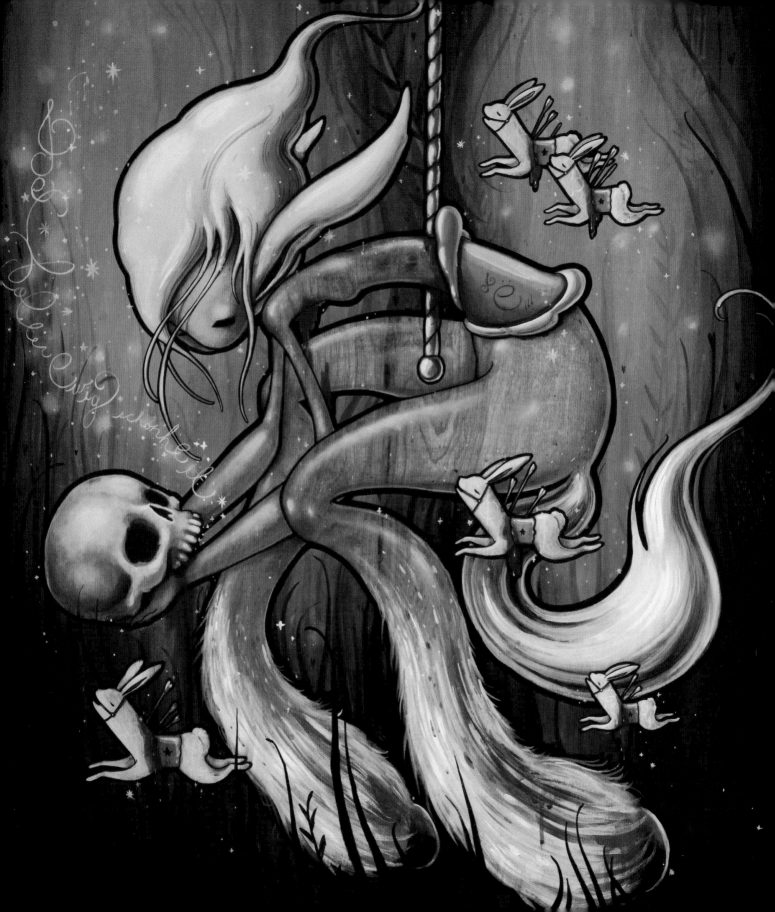

Fill Our Cups.
Drawings is graphite on paper.

p_66
Wander, Eternal Beauty.
Acrylic and ink on wood panel.

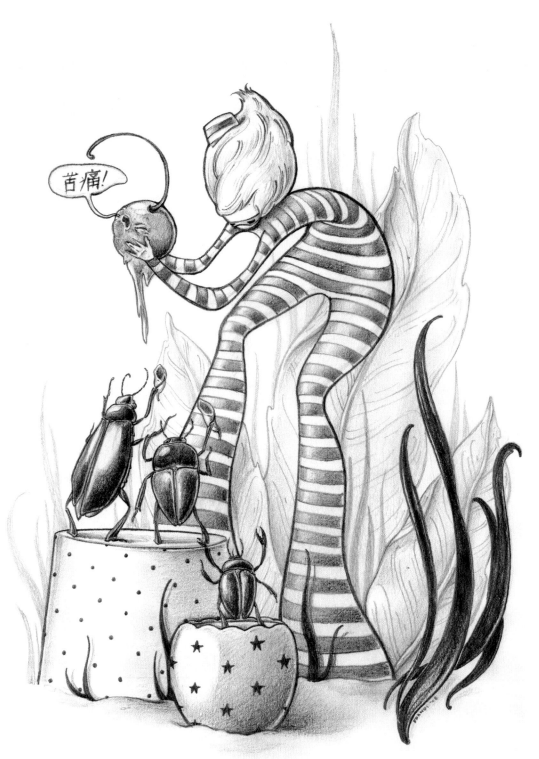

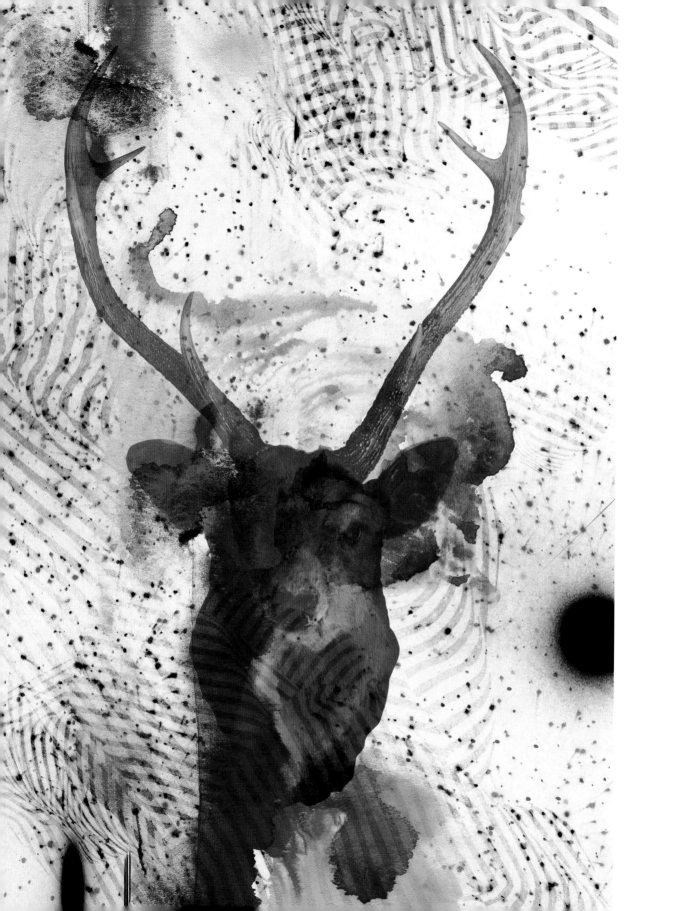

Tetsuya Toshima

visit: http://ARTas1.com/tetsuya_toshima

I am always competing against time. Time governs both life and death. The basis of time, past, present, and future, act as proof of one's existence. Therefore I sometimes fall into the illusion that I am being swept away in the flow of time. Time has a universality to it as it ticks by and bestows to my works a myriad of indefensible feelings and stories. I strive to create that universality in my works. Time is always fluid. I find the entangled fragments of stories in that fluidity and turn them into my works.

Estoy siempre compitiendo contra el tiempo. Este determina tanto la vida como la muerte. Las bases del tiempo, pasado, presente y futuro, son la prueba de la existencia de uno mismo. Por lo tanto, a veces caigo en la ilusión de que estoy siendo arrastrado por el flujo del tiempo. Este dispone de una universalidad, a la vez que pasa y otorga a mis obras miles de sentimientos e historias inexcusables. Trato de plasmar esa universalidad en mis trabajos. El tiempo siempre fluye. Encuentro los fragmentos enredados de historias en esa fluidez y los convierto en mis obras.

p_68
Deer.
Pencil, water color, air brush and acrylic.

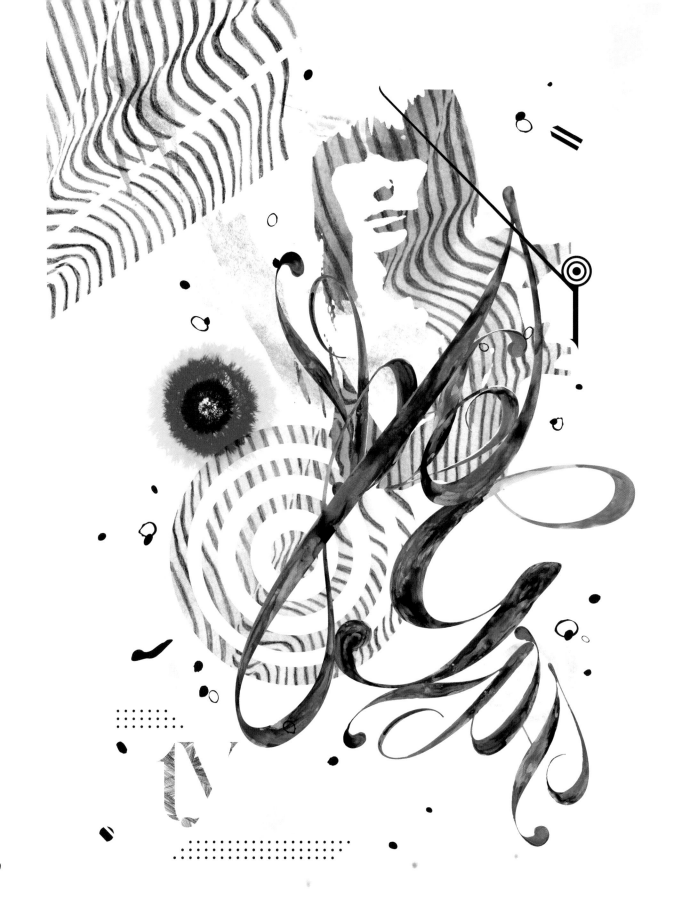

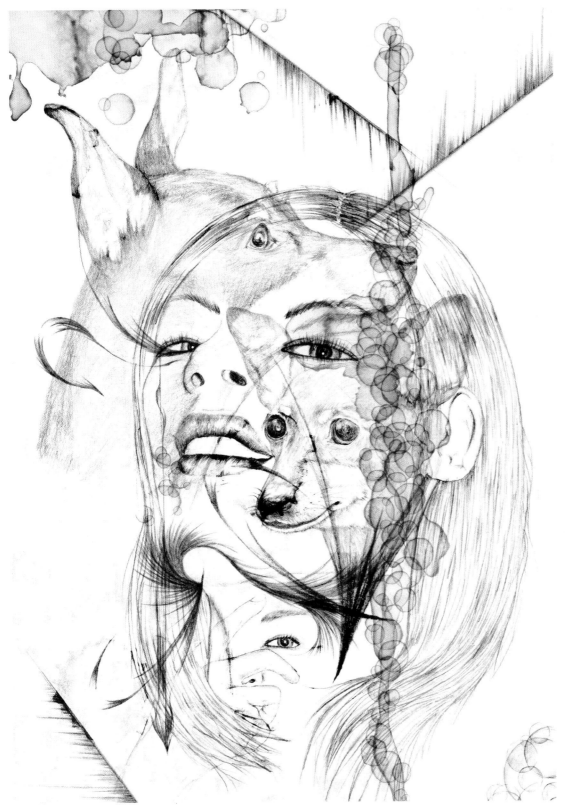

Chain.
Pencil, coffee and water color.

p_70
Interplay of Mind.
Pencil, water color, acrylic.

p_72-73
Escape and Confusion.
Pencil, pen, coffee and water
color.

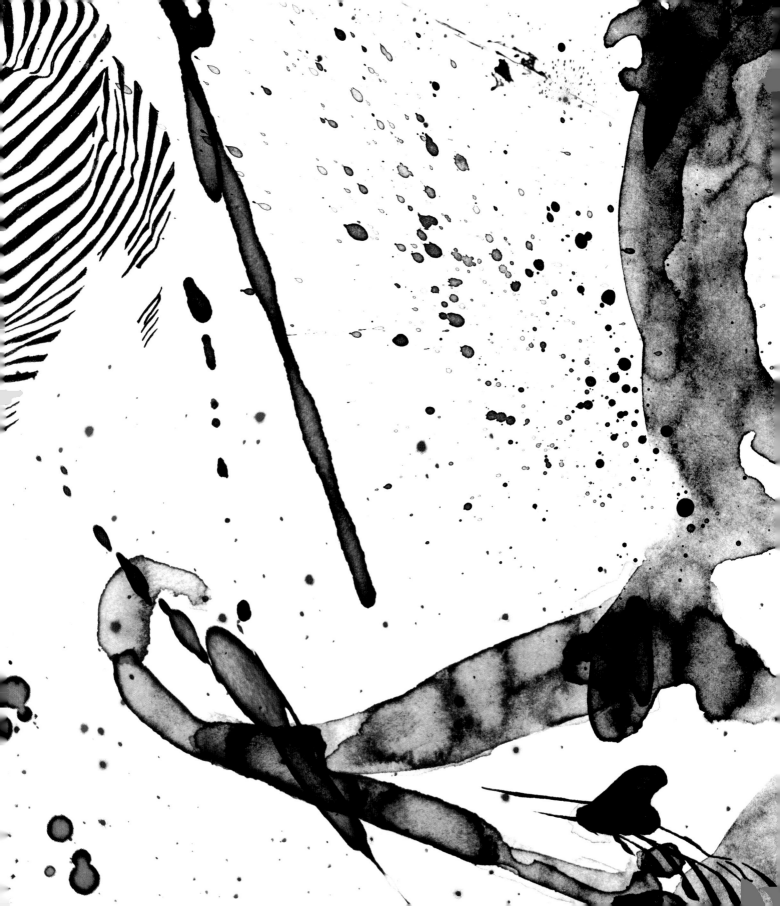

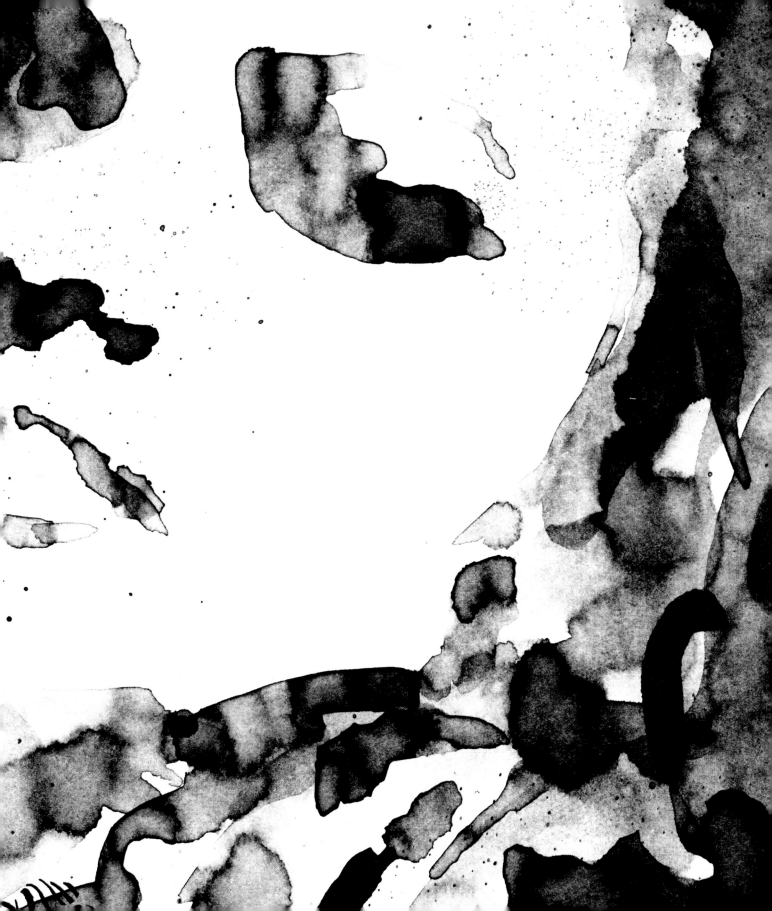

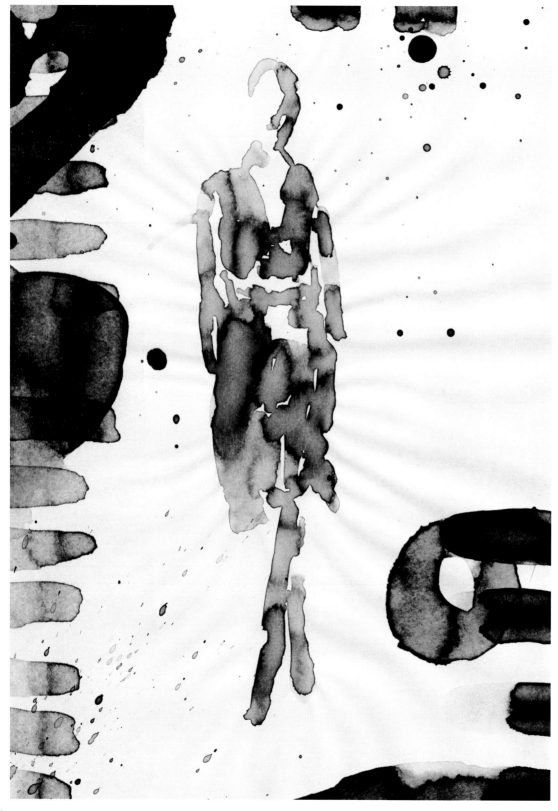

Saunter/02.
India ink, coffee, water color.

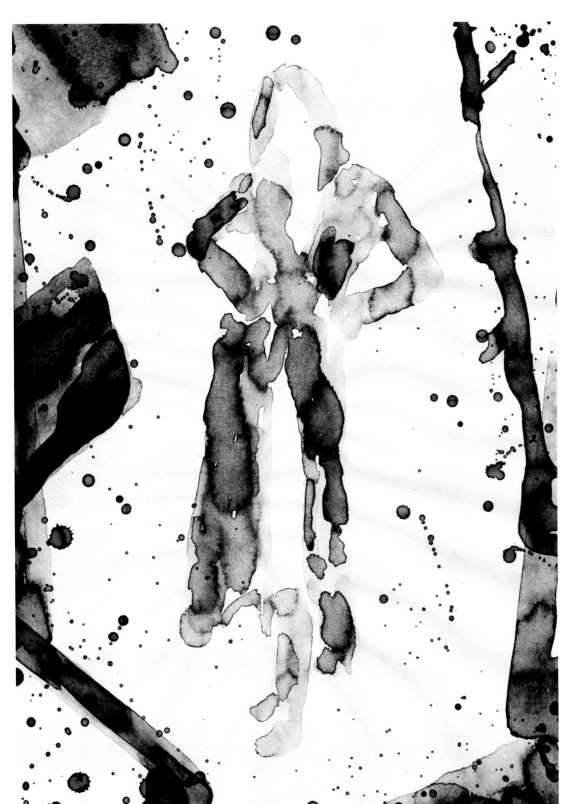

Saunter/03.
India ink, coffee, water color.

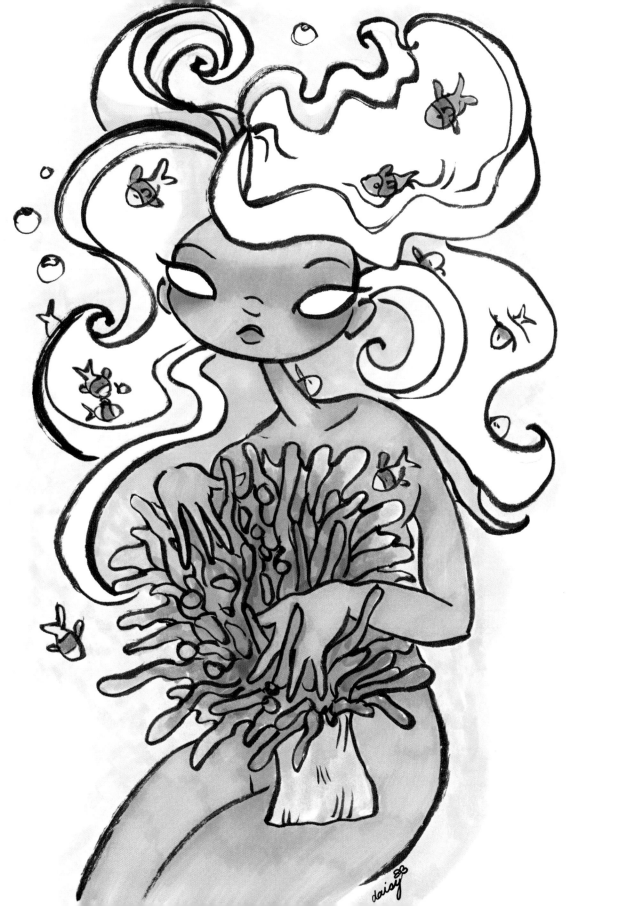

visit: www.daisychurch.com

As long as I can remember, I have loved to draw and create art. I am blessed to have had family and teachers who have always supported and encouraged my passion for artmaking, and as an adult, I find myself fortunate to work as a professional artist and animator.

I have always loved creating art about animals, women, and nature. I enjoy exploring the relationships between humanity and the natural world. In addition, I am drawn towards exploring the many juxtapositions of femininity; power and vulnerability, sensualness and sexuality, and mystery and whimsy, just to name a few examples.

For inspiration, I will often reference fashion photography, marine life, vintage fashion, Asian mythology, fairy tales, and children's literature. Artists that I am very influenced and inspired by include Audrey Kawasaki, Camilla D'Errico, Krista Huot, Danni Shinya Luo, and Brandi Milne.

I find that my work as a professional animator has positively influenced my personal art by bringing a stylized and graphic sensibility to my traditionally trained fine arts background. I am also constantly being inspired and motivated by my fellow artist/animator husband, my talented co-workers, and fellow artists and friends.

Me ha apasionado dibujar y crear arte desde que tengo uso de razón. He sido afortunada por haber tenido una familia y unos profesores que siempre me han apoyado y animado en mi pasión por el arte y como adulta, considero que tengo suerte de trabajar como artista y animadora profesional.

Siempre me ha gustado mucho crear arte relacionado con los animales, las mujeres y la naturaleza. Disfruto explorando las relaciones entre la humanidad y el mundo natural. Además, me siento atraída por explorar las muchas yuxtaposiciones de la feminidad: poder y vulnerabilidad, sensualidad y sexualidad, misterio y fantasía, sólo por nombrar algunos ejemplos. En cuanto a la inspiración, mis referencias suelen ser la fotografía de moda, la vida marina, la moda antigua, la mitología asiática, los cuentos de hadas y la literatura infantil. Los artistas que más me influencian y me inspiran son Audrey Kawasaki, Camilla D'Errico, Krista Huot, Danni Shinya Luo y Brandi Milne.

Creo que mi trabajo como animadora profesional ha influenciado de manera positiva mi arte personal al aportar una sensibilidad estilizada y gráfica a mi experiencia tradicionalmente basada en las bellas artes. También me inspiran y me motivan continuamente mi compañero, artista, animador y marido, mis talentosos companeros de trabajo, mis colegas artistas y amigos.

p_76
Anemone.
Brush pen and marker on paper.

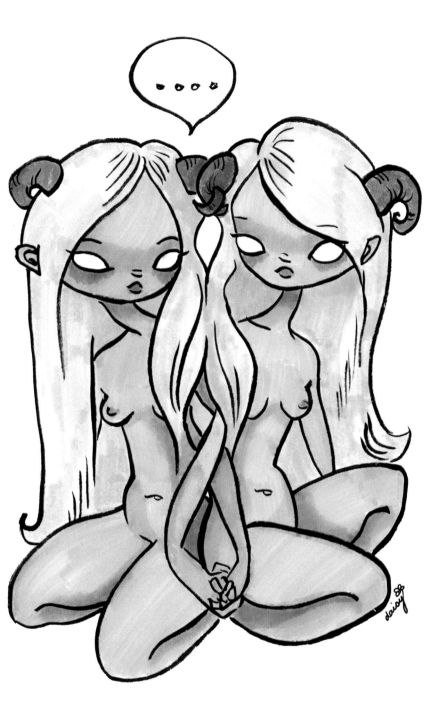

From left to right
Twins.
Brush pen and marker on paper.
Star Catcher.
Brush pen and marker on paper.

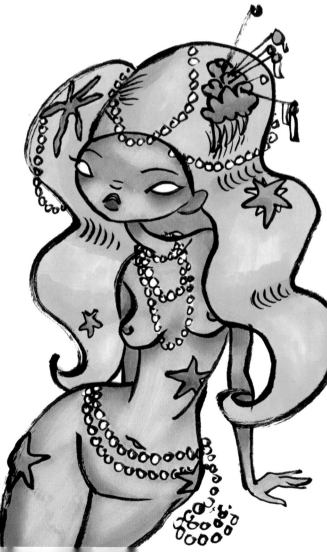

78

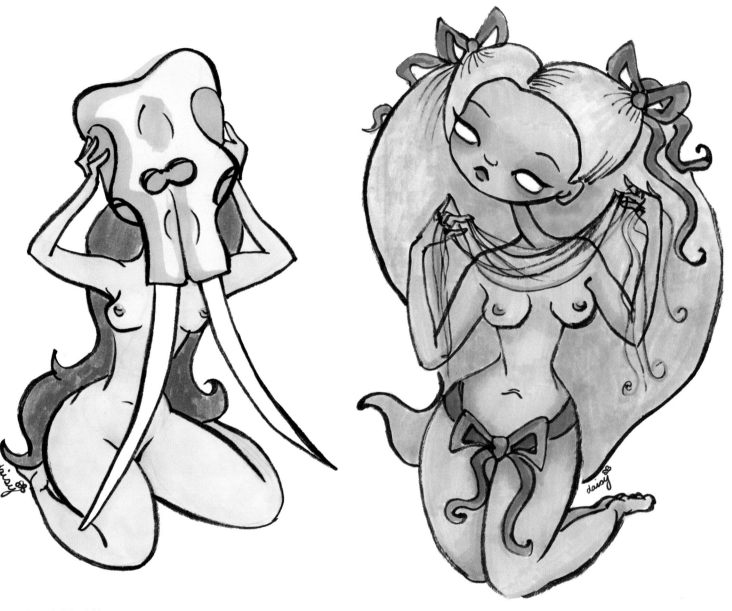

From left to right
Elephant Skull.
Brush pen and marker on paper.
Cat's Cradle.
Brush pen and marker on paper.

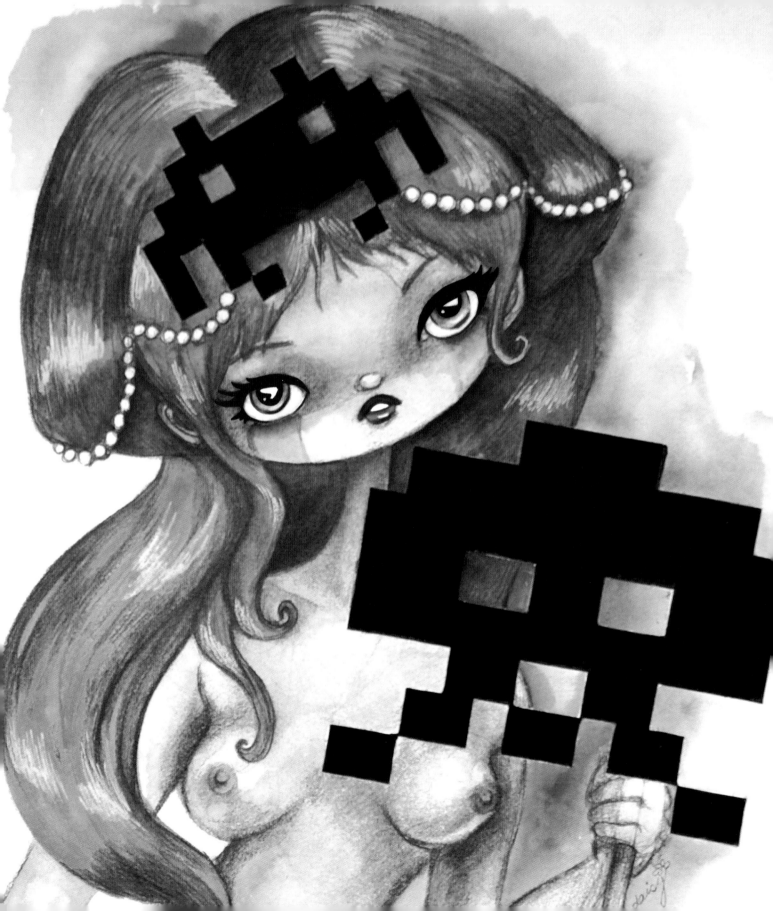

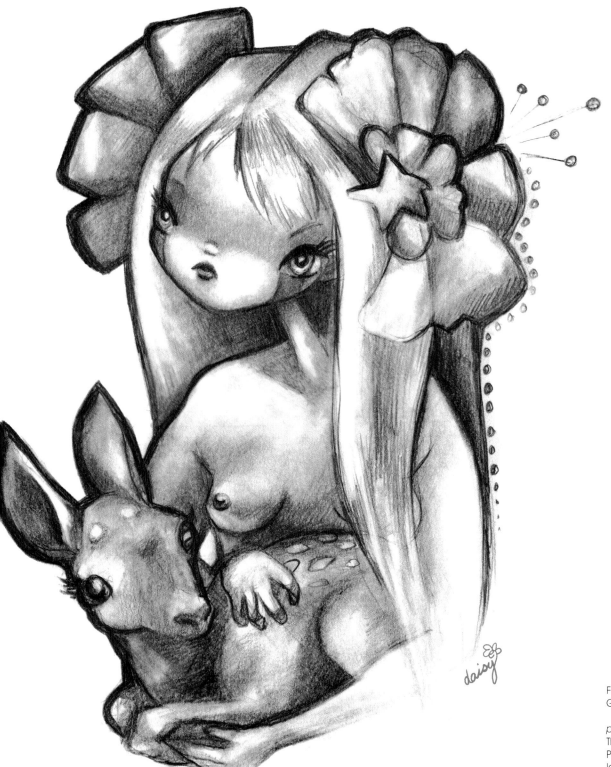

Fawn.
Graphite on paper.

p_80
The Invader.
Pencil, watercolor, and
laminate on arches paper.

Owl Head.
Brush pen and marker on
fabriano paper.

p_83
Toad Licker.
Brush pen and marker on
fabriano paper.

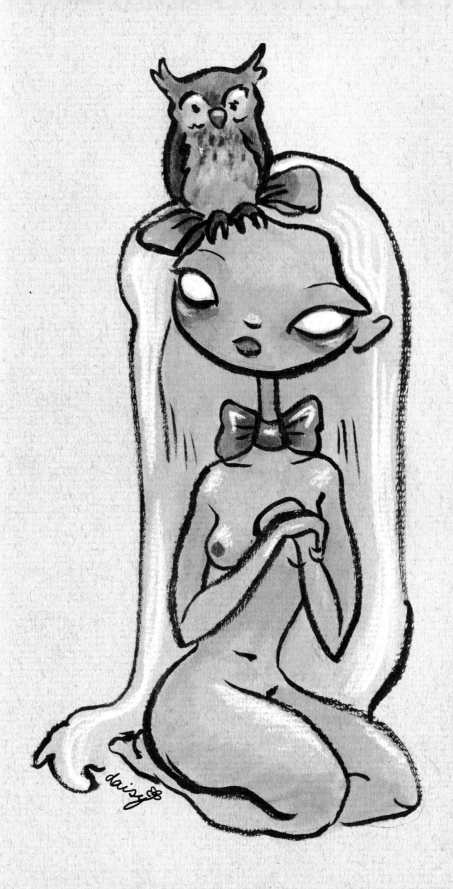

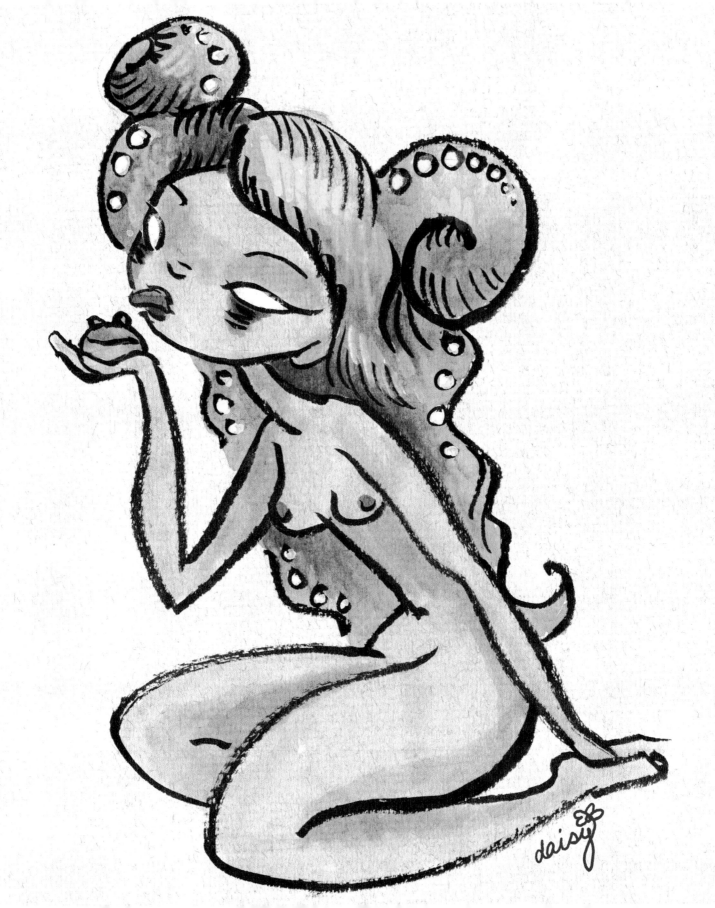

Kelly Thompson

visit: www.kellythompson.co.nz

I am originally from New Zealand, but I'm currently residing in Melbourne Australia. I have an honours degree in design with a photography major and have spent the last 6 years working as a freelance illustrator. I share my time between personal work and commercial clients and am completely passionate about the drawing process. When I am not working for a client I focus on exhibitions and creating illustrations to sell as prints.

My personal work is often inspired by models I have photographed. I always feel like a photograph isnt enough, and I need to draw my model to capture her beauty and for my own artistic satisfaction. My subjects are confident, seductive and intriguing without giving too much away. Sometimes people are offended by my subject matter, suggesting that it is a bit risque, but that makes it more intriguing for me. The whole idea of beauty is so twisted by peoples personal hang ups, sometimes something just is beautiful, and beauty doesn't last forever so why dont we just let it have its moment?
I like to begin my sketches in pencil and once resolved I work over them in black pencil, reworking my line work and tidying as I go. I then often color with either watercolour or photoshop depending on my desired outcome. Client work is always completely different, and I have rarely been asked to draw girls, but I always look at it as a challenge and take it on board, it will only make me a better artist and that is always the ultimate goal.

Soy originaria de Nueva Zelanda pero, actualmente resido en Melbourne, Australia. Tengo una licenciatura en diseño especializada en fotografía y he pasado los últimos 6 años trabajando como ilustradora autónoma. Divido mi tiempo entre el trabajo personal y los encargos para clientes y me apasiona totalmente el proceso de dibujo. Cuando no trabajo para un cliente, me centro en las exposiciones y en crear ilustraciones para venderlas como grabados.

Mi obra personal se inspira normalmente en modelos que he fotografiado. Siempre he sentido que ser fotógrafo no es suficiente y necesito dibujar mi modelo para captar su belleza y para mi propia satisfacción artística. Mis temas se centran en la confianza, la seducción y la intriga sin revelar mucho. En ocasiones, la gente se ofende por el tema, sugiriendo que es un poco atrevido, pero eso lo hace más fascinante para mí. La idea general de la belleza está muy distorsionada por los complejos personales. A veces, algo simplemente es bonito y la belleza no dura siempre, así que, ¿por qué no dejamos que tenga su momento?.
Me gusta empezar mis esbozos con lápiz y, una vez decididos, los repaso con lápiz negro, adaptando mi línea de trabajo y arreglándola sobre la marcha. Luego, suelo colorearlos con acuarela o con Photoshop, dependiendo del resultado que desee. El trabajo para el cliente siempre es completamente diferente y pocas veces me han pedido que dibuje chicas, pero siempre me lo tomo como un reto y lo asimilo. Sólo me convertirá en un mejor artista y ese siempre es el objetivo primordial.

p_84
Dluxe.
Drawn by hand using coloured pencil on recycled card.

p_86-87
Meet me at the beach house.
Drawn by hand using coloured pencil on recycled card.

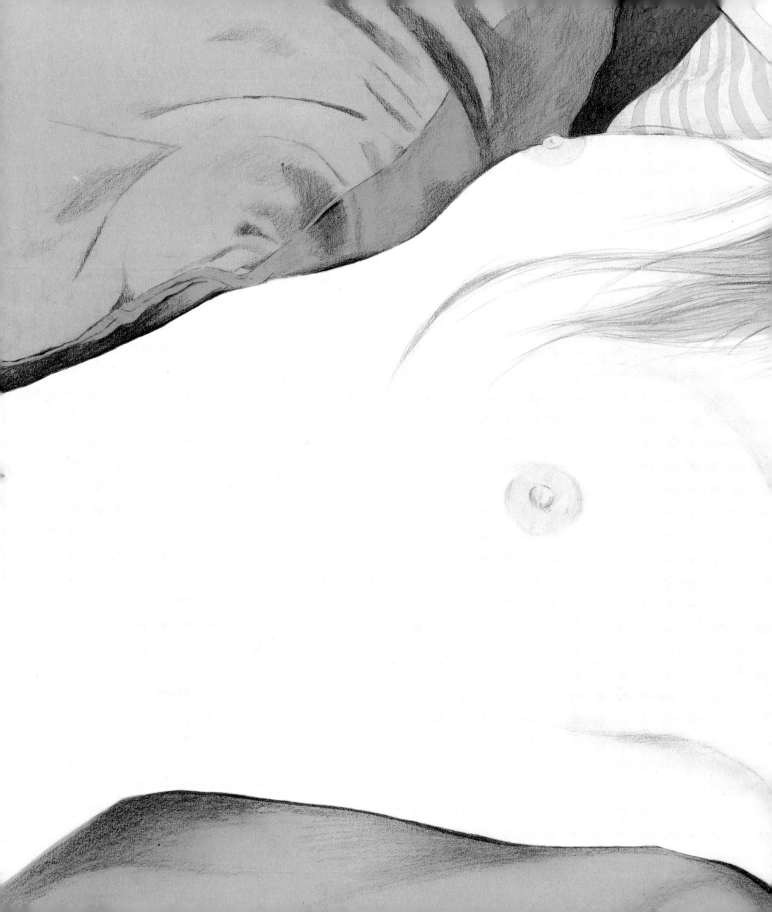

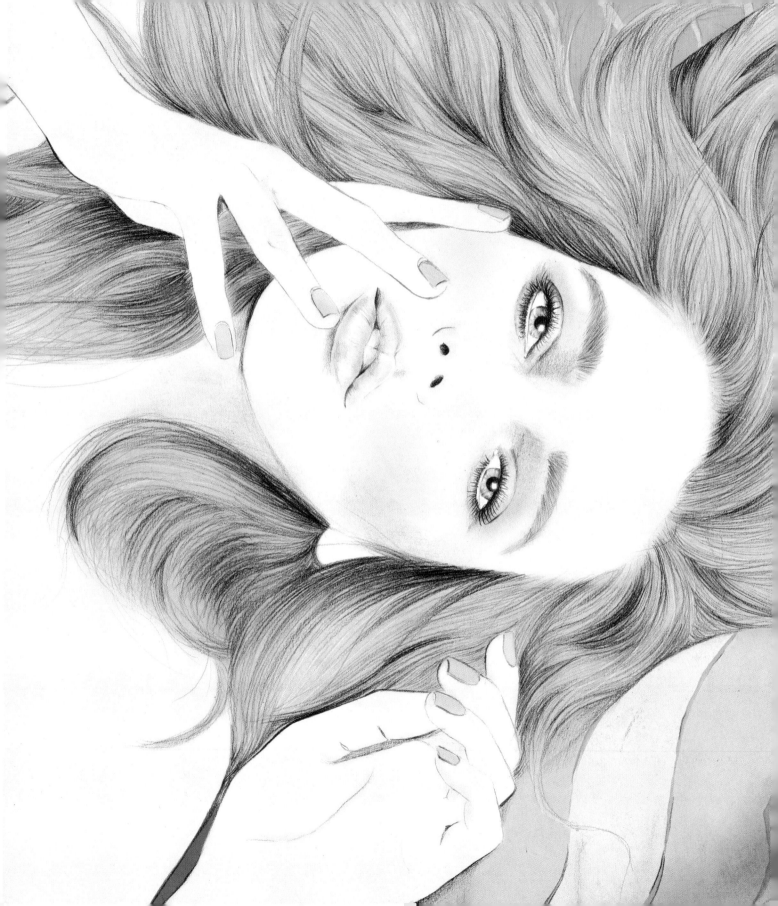

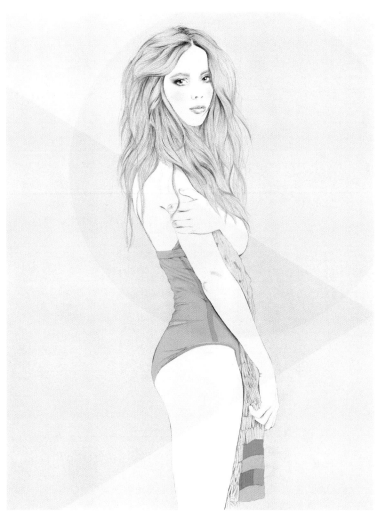

Wanna get icecream.
Drawn by hand using coloured pencil on recycled card.

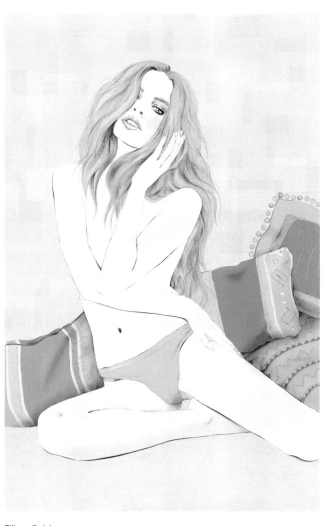

Pillow fight.
Drawn by hand using coloured pencil on recycled card.

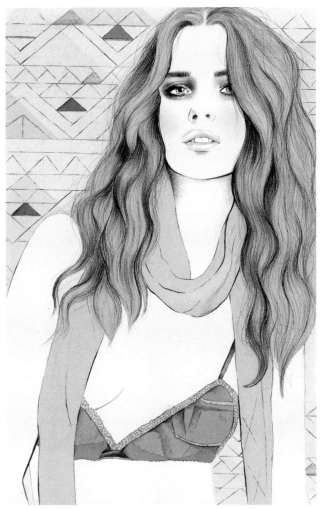

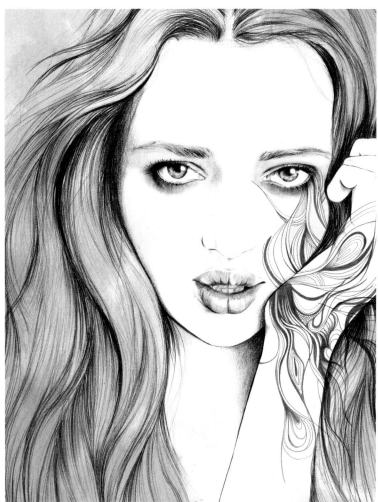

Your turn.
Drawn by hand using coloured pencil on recycled card.

Ruthie_2.
Drawn by hand using coloured pencil on recycled card.

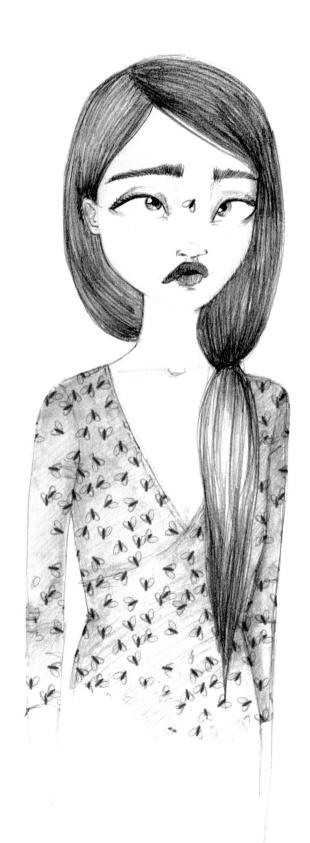

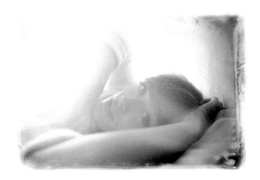

Clàudia Carrillo

visit: http://claudiacarrillo.blogspot.com

Photo profile by Olmo Reverter

Claudia Carrillo, I am a 27 year old Fashion and Interior design student from Barcelona. I adore art, love to design furniture and clothing, create patterns and, above all, DRAW!
I've been drawing since the age of reason. My mother did in fact give me pen and paper to shut me up! The only time I signed up for art class I gave the impression of being excessively orthodox, bored and academic I always drew what I wanted, how I wanted and. As a result I was always suspended from the class by the art and crafts teacher in order to do my homework how I jolly well felt like it!
I possess a ridiculous amount of pencils since my technique is always down to pencil and paper, the source of my improved progress. Although my illustrations are created in pencil, from start to finish, at times I resort to water colours, coloured pencils and acrylic crayons as a complement, especially since I adore pastel colours such as flamenco pink, bottle green and above all red and black!

My line of work is somewhat chaotic, I draw all over the place, at home, in bars, but, since I'm at it constantly it's also consistent and sincere. Devoid of inspiration, my Illustrations relate to my experiences, my feelings, my emotions, my premenstrual conditions, my ill humour, even the affect the surroundings have on me as a person… Every drawing is a part of me.

Soy Claudia Carrillo, tengo 27 años y soy de Barcelona. He estudiado Interiorismo y Moda. Me encanta el arte, diseñar muebles, crear ropa, inventarme estampados y sobre todo DIBUJAR!
He dibujado desde que tengo uso de razón, de hecho mi madre me daba papel y lápiz para que estuviera calladita! La única vez que me apunté a clase de dibujo me pareció demasiado ortodoxo, aburrido y muy academicista, así que he dibujado lo que he querido como he querido desde siempre, por eso en el colegio el maestro de plástica siempre me suspendía la asignatura, porque hacía los deberes como realmente me daba la gana!
Mi técnica es siempre papel y lápiz, es en la que me desenvuelvo mejor, tengo tantos lápices que es una locura! A pesar de siempre empezar y acabar las ilustraciones en lápiz, de vez en cuando utilizo como complemento acuarelas, lápices de colores y acrílicos, ya que me encantan los colores pastel como rosa flamenco o el verde hospital y sobre todo el rojo y el negro!

Mi línea de trabajo es bastante caótica porque dibujo en cualquier parte ya puede ser en casa como en un bar, pero es constante y sincera, ya que siempre estoy haciéndolo. La inspiración no existe, yo dibujo a partir de lo que me pasa, de cómo me siento, de mis emociones, mis estados premenstruales, mi mal humor, aunque también de cómo el entorno reacciona sobre mi persona… Cada dibujo es una parte de mi.

p_90
Mosca cojonera.
Graphite on paper.

Dora Romero.
Graphite on paper.

Corazonada.
Hearts are Anna Esparza.
Mixed media on paper.

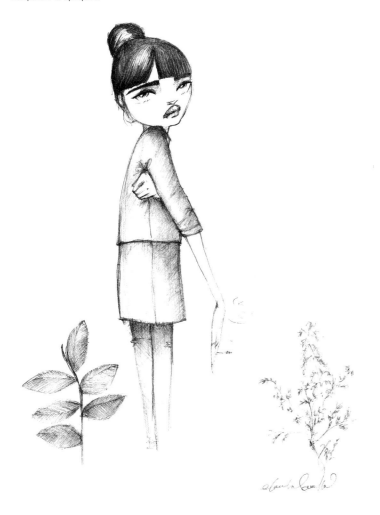

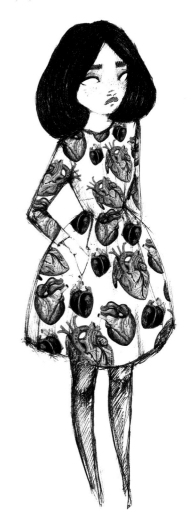

From left to right: p_93
Hitler vive en ti.
Graphite on paper.
Sin título.
Graphite on paper.

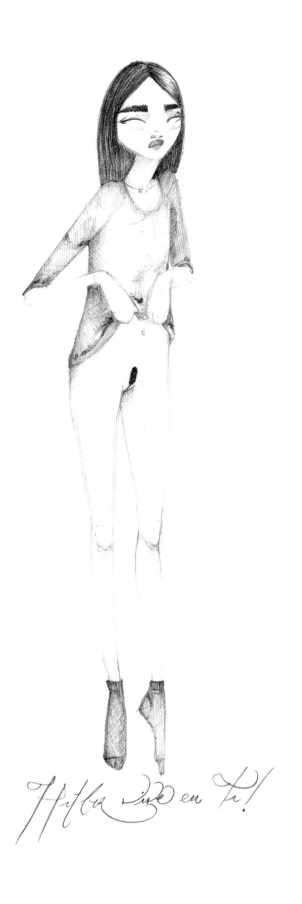

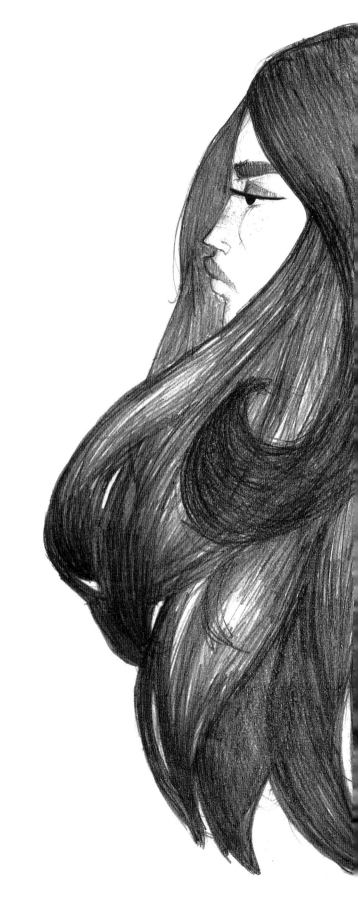

Mamiferos y Oviparos.
Graphite on paper.

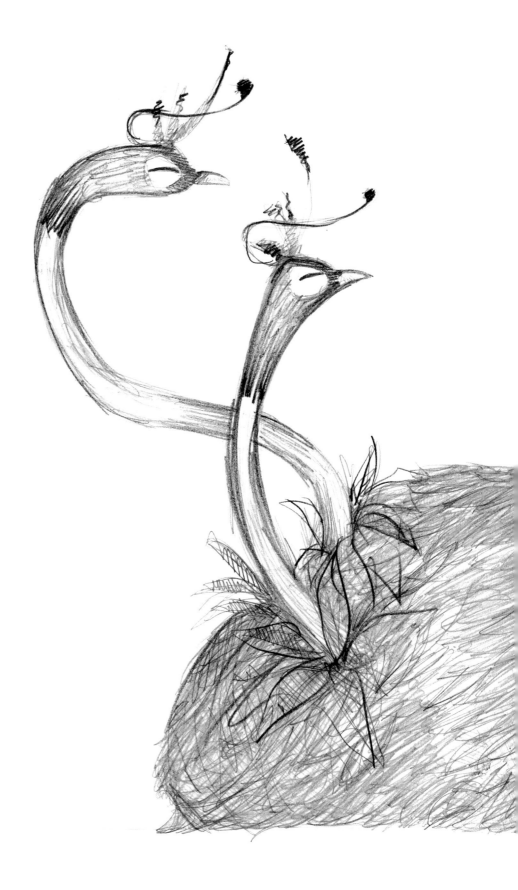

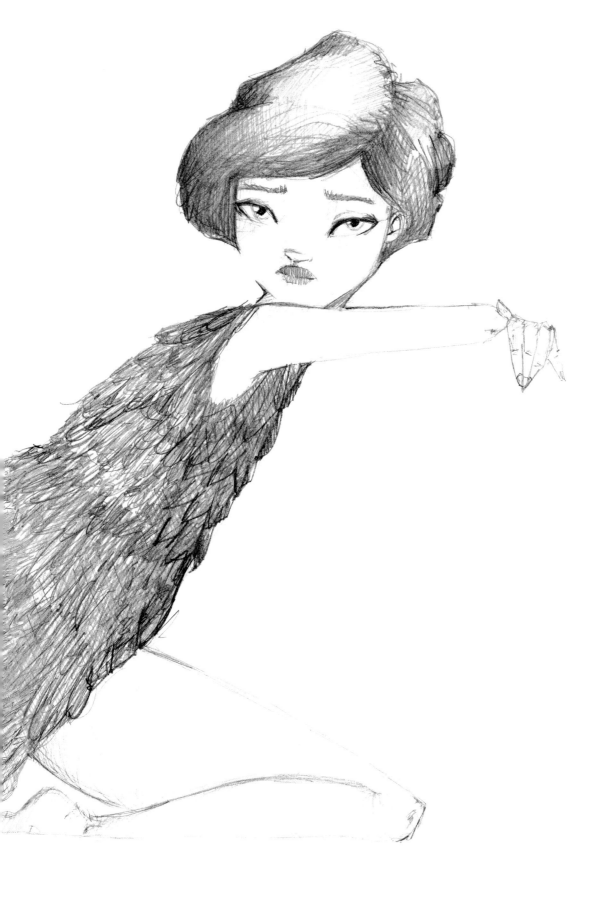

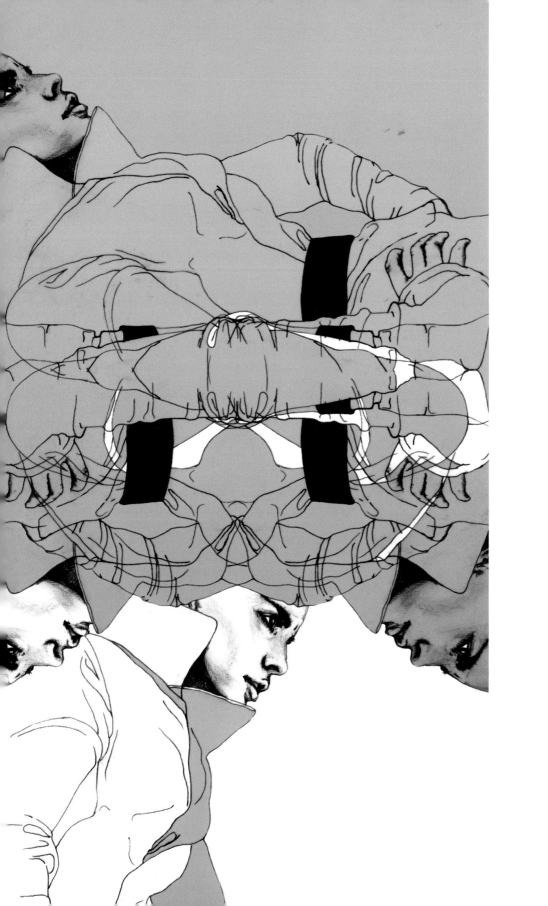

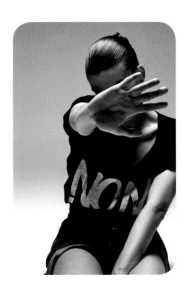

Sabine Pieper

visit: www.sabinepieper.com

I'm a freelance illustrator based in Berlin, Germany. I was born in Germany in 1980 and have always been passionate about drawing, since my childhood days. After I've worked many years as a photographer, I found it more and more exciting to illustrate, to draw the pictures, not to capture them with the lens of my camera. What I love about working as a fashion illustrator - it combines my interest in fashion, art and illustration. When I'm illustrating, I have the possibilty to create pictures in a much more playful way than it would be possible if I would photograph.

I guess my illustrations are not totally "handmade" - I always start a new work with a handmade drawing (pencil, ink, watercolour, ...) but finally I digitize the drawing and the photoshop part of the work starts. Working digital just gives me so much more possibilities. Often I do not really know what the final picture will look like, it's always a process and sometimes the result differs from the first ideas or sketches. I personally love handmade illustrations, they got a different character than purely digital ones.
Inspiration for my work comes from magazines, exhibitions, books, music, but also from the everyday life and people themselves. It's difficult to say where the idea for the final piece comes from, often it's just a feeling and a little idea in the head, and at the end of the process something growed.

Soy una ilustradora autónoma que vive en Berlín, Alemania. Nací en dicho país en 1980 y siempre me ha apasionado el dibujo, desde mi infancia. Después de haber trabajado muchos años como fotógrafa, descubrí que ilustrar era mucho más excitante; dibujar las imágenes, no capturarlas con el objetivo de mi cámara. Lo que me encanta de trabajar como ilustradora de moda es que combina mi interés por el arte y la ilustración. Cuando realizo las ilustraciones, tengo la posibilidad de crear imágenes de una manera mucho más pícara de lo que sería posible si las fotografiara.

Supongo que mis ilustraciones no están «hechas a mano» del todo: siempre empiezo un nuevo trabajo con un dibujo a mano (a lápiz, tinta, acuarela…) pero al final, digitalizo el dibujo y comienza la parte de trabajo en Photoshop. Trabajar digitalmente me ofrece muchas más posibilidades. No suelo saber cómo quedará la imagen final. Siempre es un proceso y a veces, el resultado difiere de las primeras ideas o bocetos. Personalmente, me encantan las ilustraciones hechas a mano, tienen un estilo diferente a las puramente digitales.
La inspiración para mis obras me viene de revistas, exposiciones, libros, música, pero también de la vida diaria y de la gente en sí. Es difícil decir de dónde surge la idea de la última pieza. A menudo es sólo una sensación y una pequeña idea en la cabeza y al final del proceso, algo que ha evolucionado.

p_96
Question.
Pencil, ink.

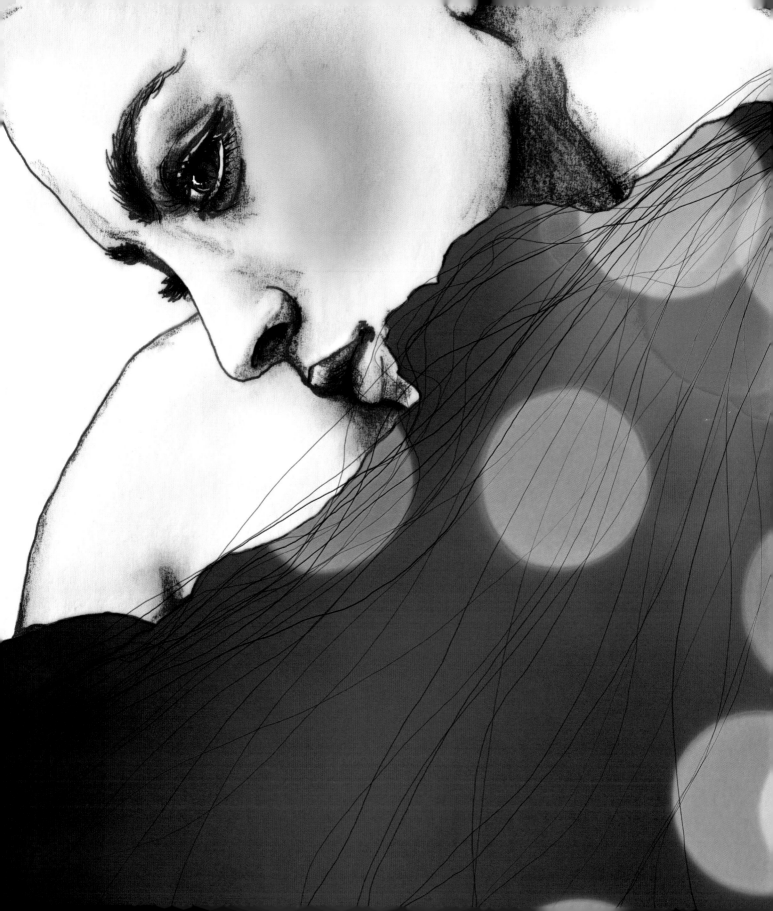

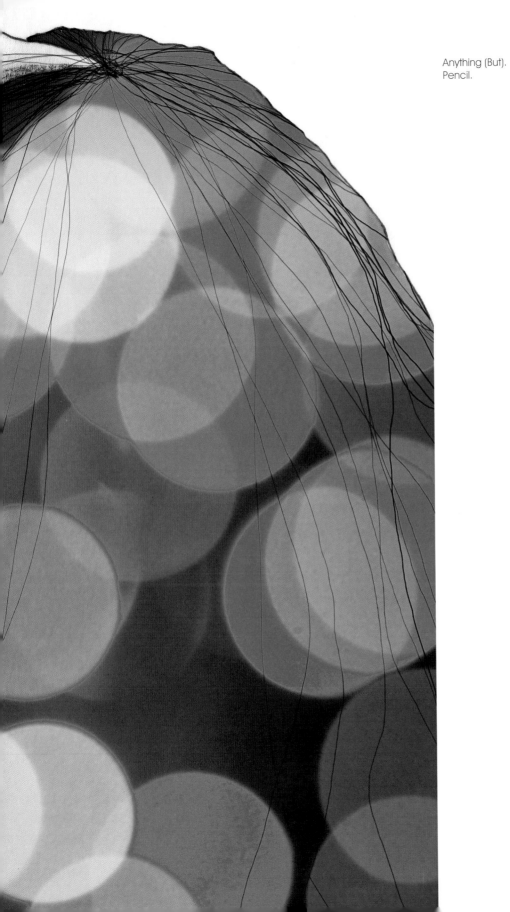

Anything (But).
Pencil.

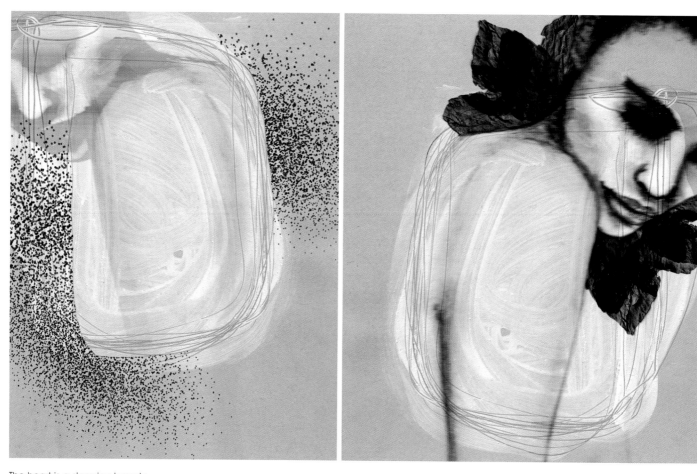

The heart is a sleeping beauty.
Pencil, ink, acrylic paint.

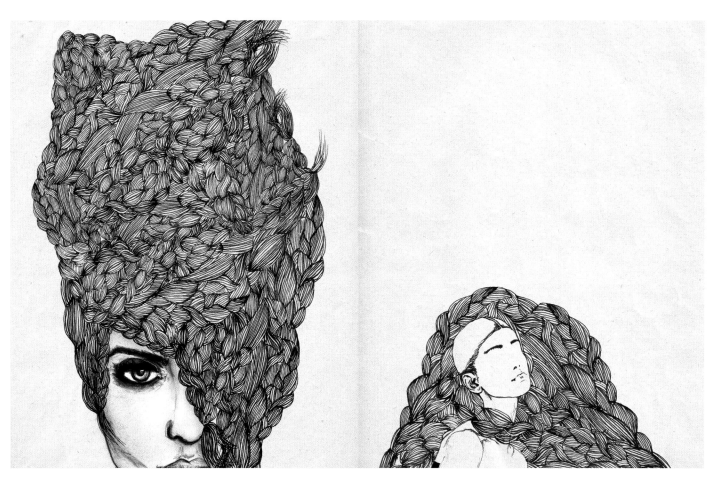

Untitled.
Pencil, watercolour.

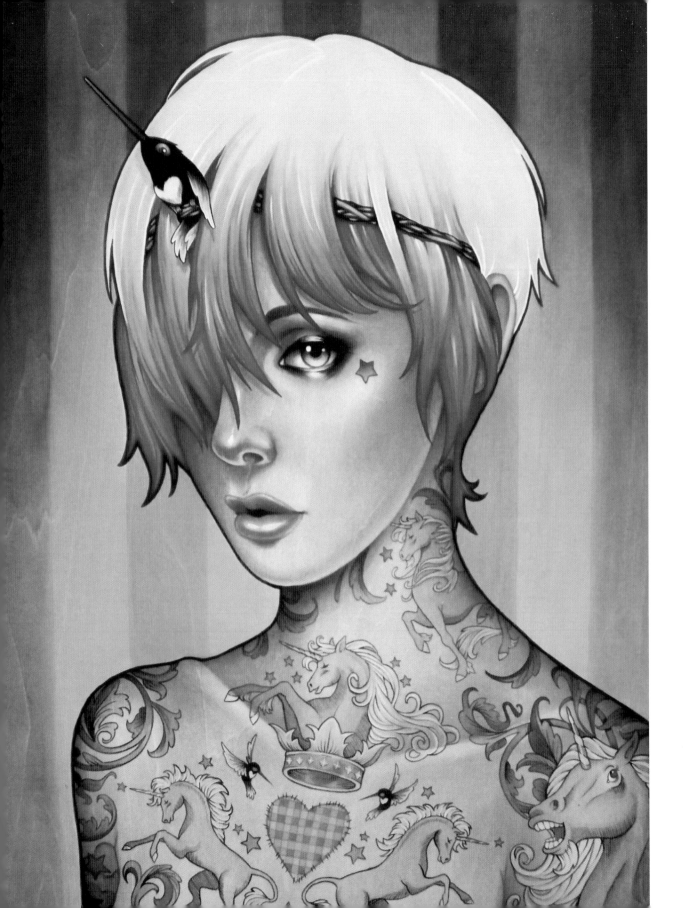

Glenn Arthur

visit: http://glennarthurart.com/

"My name is Glenn Arthur. I'm a self taught artist from Southern California. My artwork is more illustrative and graphic looking although it's done in a traditional manner. My tools are generally acrylic paint on wooden panels though I also work in watercolor, colored pencil, graphite, and ink as well. It all depends on the type of image I want to create.

I'm very much inspired by emotion. I'm also inspired by duality such as love and heartbreak, life and death, joy and sorrow. Once I'm inspired to start a piece I begin in my sketchbook with doodles then make a final cleaned up sketch as a value study. After that I transfer the drawing onto a wood panel where I begin to paint. I start with light washes of colors, layering constantly until I finally reach the desired look. I finish up the piece with outlines and detail work.

Having my work seen around the world is such a thrill to me! I think I'll always be in shock about that. I absolutely love the people who follow my artwork. It's such a blessing to have that kind of support. I can never express enough gratitude to them."

«Me llamo Glenn Arthur. Soy un artista autodidacta del sur de California. Mi material tiene un aspecto más ilustrativo y gráfico, aunque está hecho de una manera tradicional. Mis herramientas son, generalmente, la pintura acrílica sobre paneles de madera, aunque también trabajo con acuarelas, lápices de colores, grafito y tinta. Todo depende del tipo de imagen que quiera crear.

Me inspiro mucho en la emoción, también me inspira la dualidad, como el amor y el desengaño, la vida y la muerte, la alegría y la pena. Una vez que estoy inspirado para empezar una pieza, comienzo garabateando en mi libro de bocetos, luego realizo un boceto final en limpio como un estudio de valor. Después, paso el dibujo a un panel de madera donde empiezo a pintar. Comienzo con capas suaves de colores, pintando encima constantemente hasta que, finalmente, consigo el aspecto deseado. Acabo la pieza con los contornos y los detalles.
¡Me emociona ver mi obra por todo el mundo! Creo que siempre me impactará. Me apasiona la gente que sigue mis ilustraciones. Es una bendición tener ese tipo de apoyo. Nunca puedo expresarles suficiente gratitud.»

p_102
Some Call It An Obsession.
Acrylic on wood.

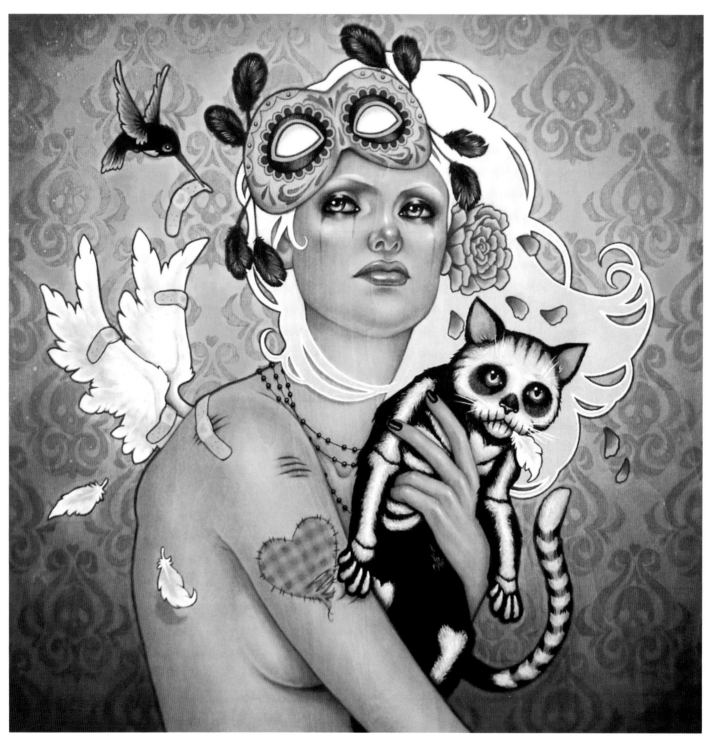

A Mask To Conceal With Bandages To Heal.
Acrylic on wood.

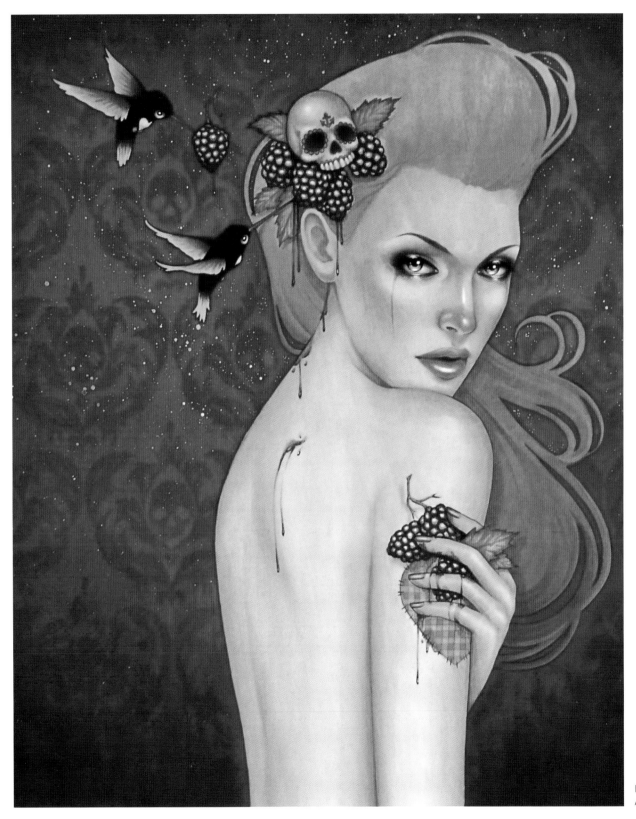

Her Forbidding Berries.
Acrylic on wood.

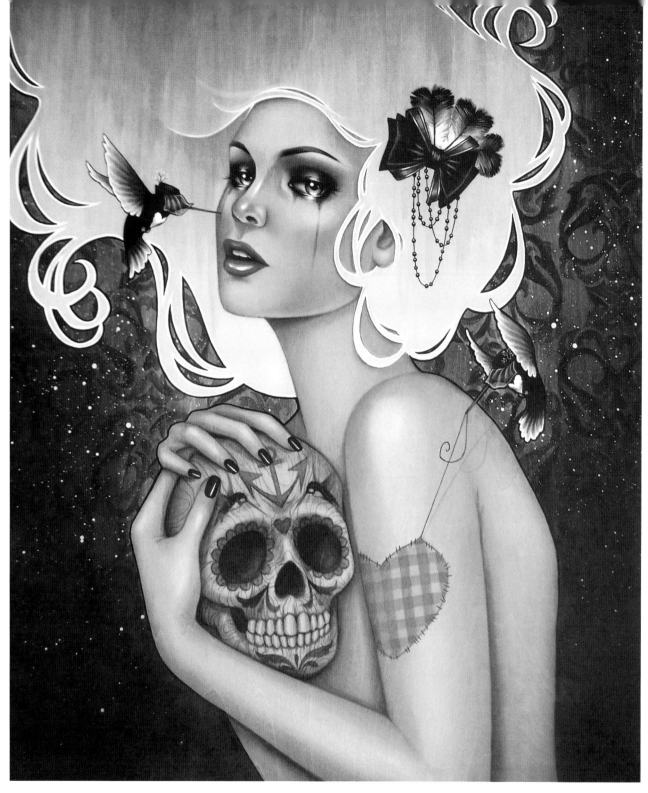

In Love With Lament.
Acrylic on wood.

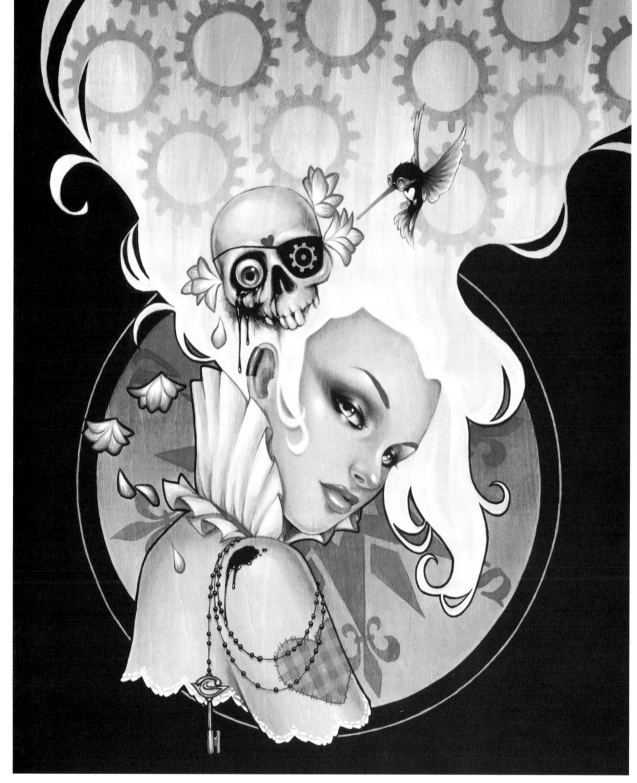

Her Fatal Fascination.
Acrylic on wood.

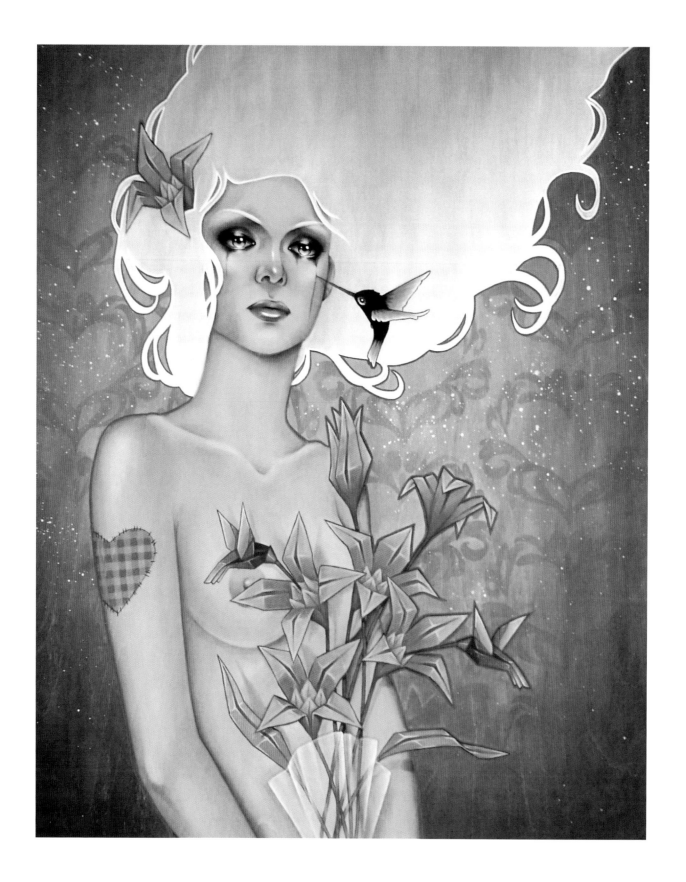

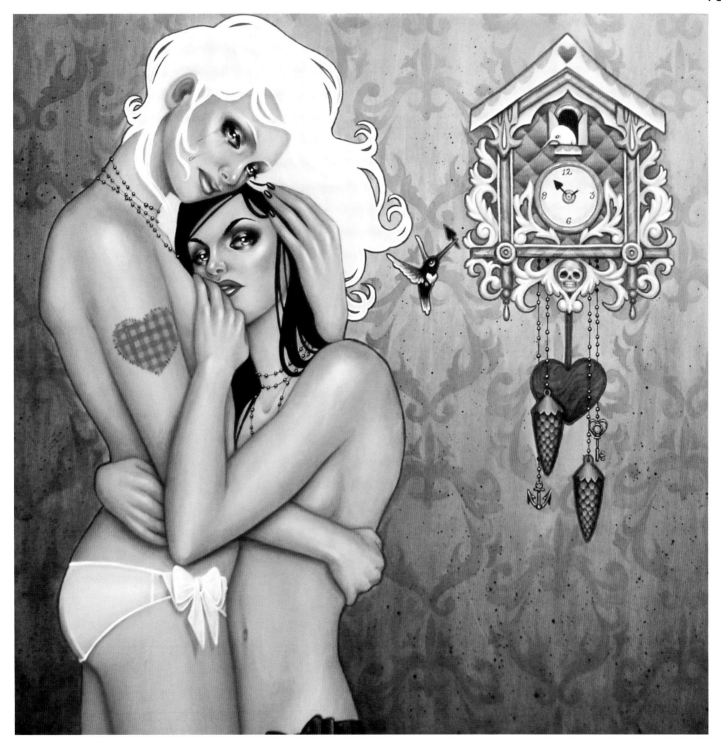

Time Stands Still When We Embrace.
Acrylic on wood.

p_108
Your Love Is Paper Thin.
Acrylic on wood.

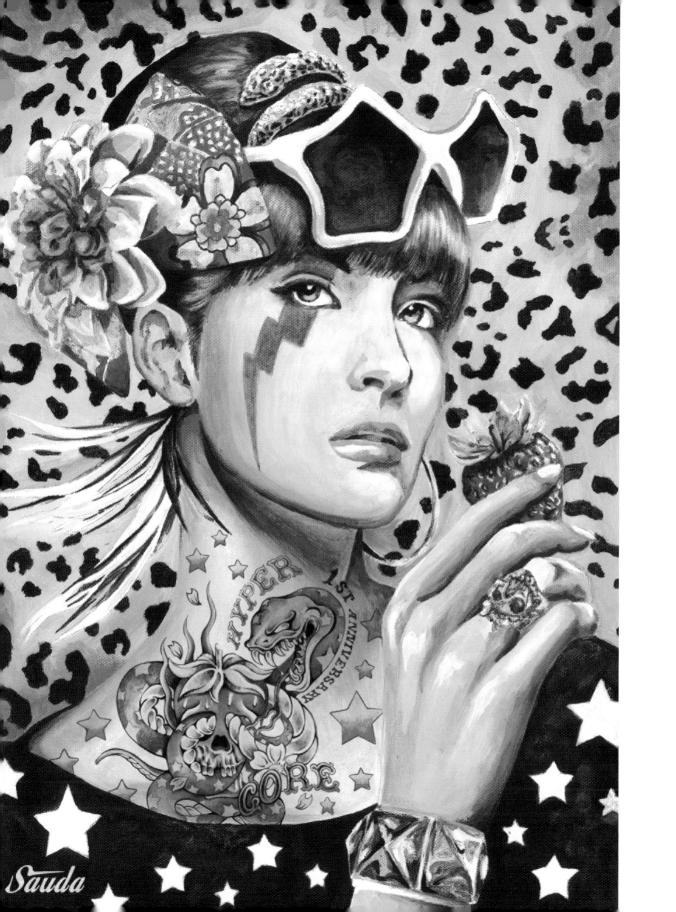

Kaoru Sauda

visit: http://ARTas1.com/kaoru_sauda

I have worked on many visual projects including posters for MTV, Levi's, FIFA 2010 and Budweiser. I had exhibitions in New York Gallery LOVE & PEACE in 2006, China, Korea & Japan (3 countries) in 2008 and attended the exhibitions. I enjoy exchanging social interests with overseas creators. I appeared in the live events SUMMER SONIC and UNIVERSAL CITIYWALK OSAKA, and have been published and broadcasted through the music magazine NME Web and MTV. I started getting attention from the media as a "live art performer" in and outside of Japan.
Currently, I am working on a wall painting in HUMMER JAPAN's basement garage, a collabration item at RODEO CROWNS which is a popular lady's brand, CD jackets for famous musicians such as former Sumo Grand Champion KONISHIKI Yasokichi, PARSONZ, and I make a variety of concert goods for musician Tsuyoshi Nagabuchi. I am still expanding my areas of work.

I have been using the same techniques since I was a student. I paint and draw both delicate and bold illustrations using acrylic paints and color pencils. My ideas come in two major genres, one comes from music and nature, and the other comes from social issues or conflicts around me. I've been trying to be concious to express both art and entertainment in my artworks, and for the audience to feel my messages.

He trabajado en muchos proyectos visuales, incluyendo posters para la MTV, Levi's, FIFA 2010 y Budweiser. He expuesto en la Galería de Nueva York Love & Peace, en el 2006; en China, Corea y Japón, en el 2008 y he acudido a las exposiciones. Disfruto intercambiando ideas con creadores extranjeros. Aparecí en los eventos en directo Summer Sonic y Universal Catwalk Osaka y he salido en publicaciones y retransmisiones de la revista de música NME y de la MTV. Empecé a llamar la atención de los medios por ser un «artista en directo» dentro y fuera de Japón.
Actualmente, estoy trabajando en una pintura mural en el garaje subterráneo de Hummer Japón; en un artículo colaborativo para Rodeo Crowns, una famosa marca para mujeres; en carátulas de CD para músicos famosos como el ex Gran Campeón de Sumo Konishiki Yasokichi, Parsonz; y realizo una variedad de productos para conciertos para el músico Tsuyoshi Nagabuchi. Aún sigo ampliando mis áreas de trabajo.

He estado empleando las mismas técnicas desde que era estudiante. Pinto y dibujo ilustraciones tanto delicadas como atrevidas, utilizando pinturas acrílicas y lápices de colores. Mis ideas vienen de dos géneros principales: uno surge de la música y la naturaleza y el otro, de los temas o conflictos sociales que me rodean. He estado intentando ser consciente para expresar tanto el arte como el entretenimiento en mis obras y para que el público sienta mis mensajes.

p_110
Leopard & Strawberry Girl.
Painted with acrylic paints.

Maiko.
Painted/drawn with
acrylic paints & water
color pencils.

p_113
Santa Claus Marilyn.
Painted/drawn with
acrylic paints & water
color pencils.

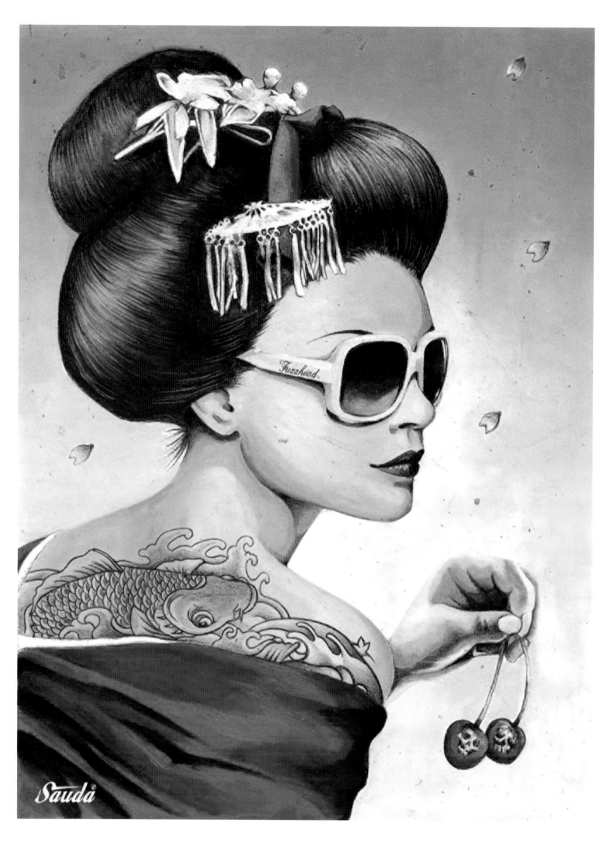

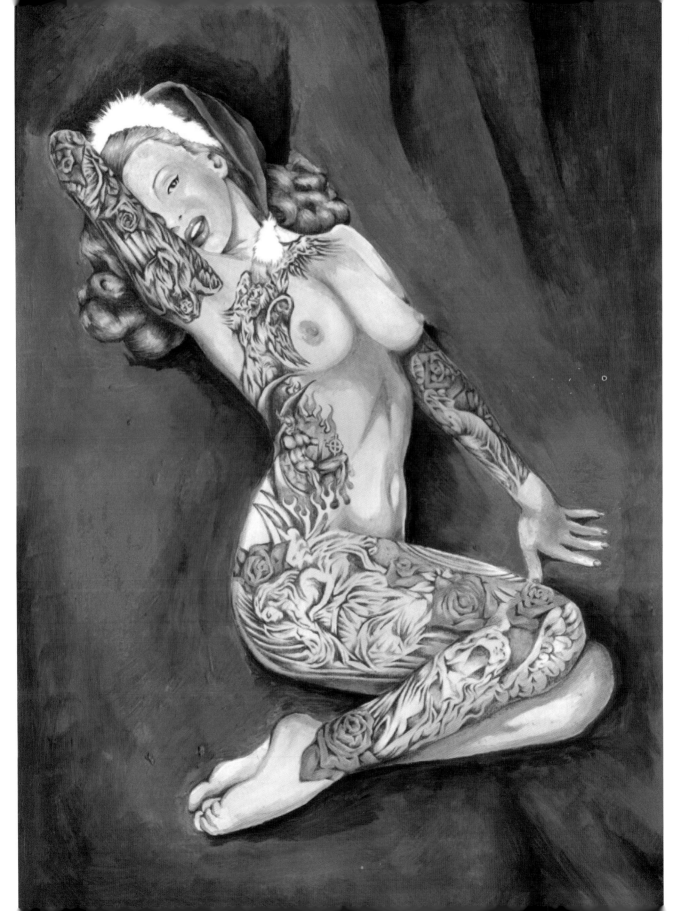

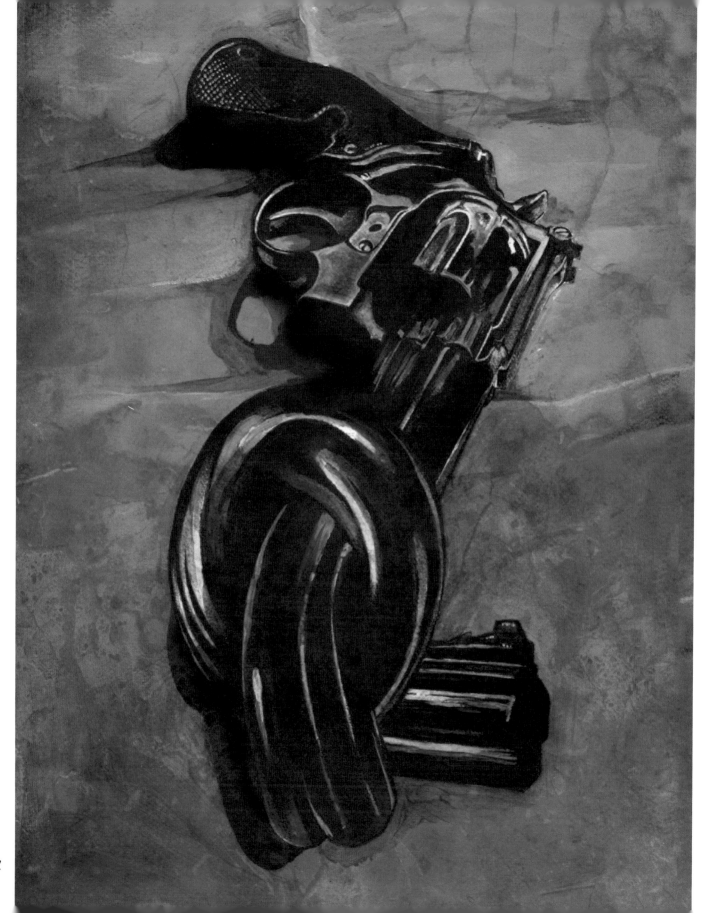

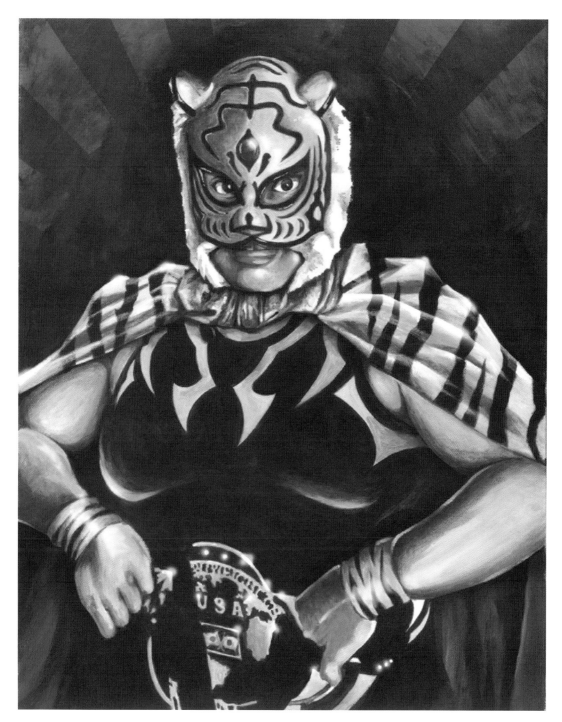

Professional wrestler.
Painted with acrylic paints, by layering colors roughly so that
the canvas's texture appears coarser.

p_114
Love and Peace.
Painted/drawn with acrylic paints & water color pencils.

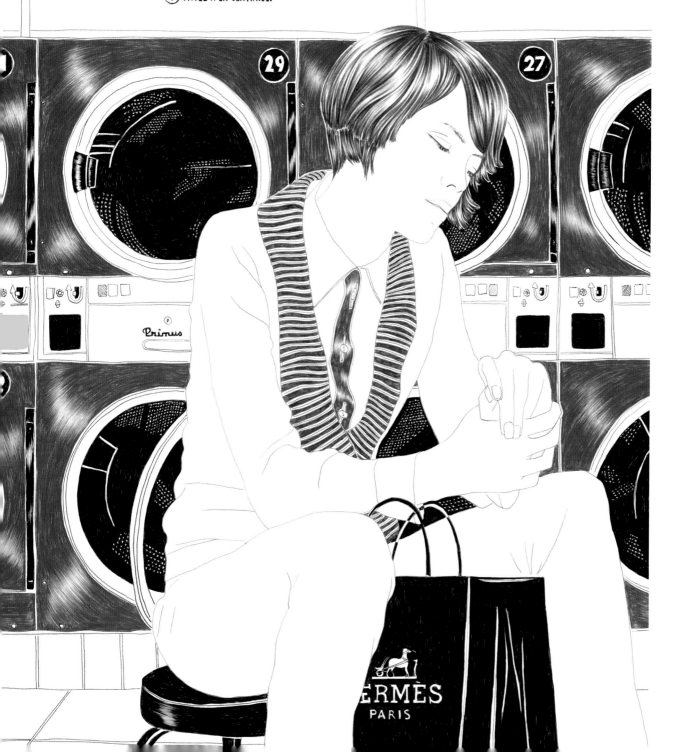

Carine Brancowitz

visit: www.carinebrancowitz.com

When I was a kid I was more into music than anything. Later I started to develop a strong interest for Art... Italian Renaissance, Ancient Greek sculptors... Now I'm an illustrator. I studied illustration, sceen print & lithography at the Ecole Estienne in Paris.
I draw with ballpoint pens, felt tip pens and sometimes pencils. It's such minimalist and a portable medium and you're able to work everywhere. I've worked for fashion brands such as Testoni, Celine, Iceberg, Kitsuné. Also, a lot of international publications such as Vogue, Nylon, Dazed&Confused, Elle, Arena, Cosmopolitan...
I like working for the fashion industry. I'm really fond of drawing fabrics, patterns, textures and creatures! But what I prefer is my personal work, and I try to exhibit my new drawings once a year.
I spend an awful lot of time thinking of the next drawing. Changing directions, where to draw details? which color? It's a long and complicated process, a pyramidal structure. I draw a pencil outline on the paper when the image is finished in my head. Then when everything is right I draw with the pen and erase the draft. I work everyday, I'm always focused.

Sometimes i listen to music or audio books or political shows on radio. My work is always inspired by today's events. I selfishly draw for myself, encapsulating moments of my existence in each drawings.

Cuando era una niña, me interesaba más la música que cualquier otra cosa. Más tarde, comencé a desarrollar un fuerte interés por el Arte... el Renacimiento italiano, escultores de la Antigua Grecia. Ahora soy ilustradora. Estudié ilustración, serigrafía y litografía en la École Estienne en París. Dibujo con bolígrafos, rotuladores y a veces, lápices. Es un material tan minimalista y portátil que puedes trabajar en cualquier lugar. He trabajado para marcas de moda como Testoni, Celine, Iceberg o Kitsuné, y, también, para muchas publicaciones internacionales como Vogue, Nylon, Dazed&Confused, Elle, Arena, Cosmopolitan...
Me gusta trabajar para la industria de la moda. ¡Me fascina dibujar telas, patrones, texturas y creaciones! Sin embargo, prefiero mi trabajo personal, e intento exponer mis nuevos dibujos una vez al año.
Paso muchísimo tiempo pensando en el próximo dibujo: cambiando direcciones, dónde dibujar los detalles, qué color. Es un proceso largo y complicado, una estructura piramidal. Dibujo un contorno a lápiz en el papel cuando la imagen está acabada en mi cabeza. Dibujo con el bolígrafo y borro el boceto. Trabajo a diario, siempre estoy concentrada.

A veces, escucho música, audiolibros o programas políticos en la radio. Mi obra siempre se inspira en los sucesos actuales. Egoístamente, dibujo para mí misma, condensando momentos de mi existencia en cada dibujo.

p_116
Carmes.
Pen on paper.

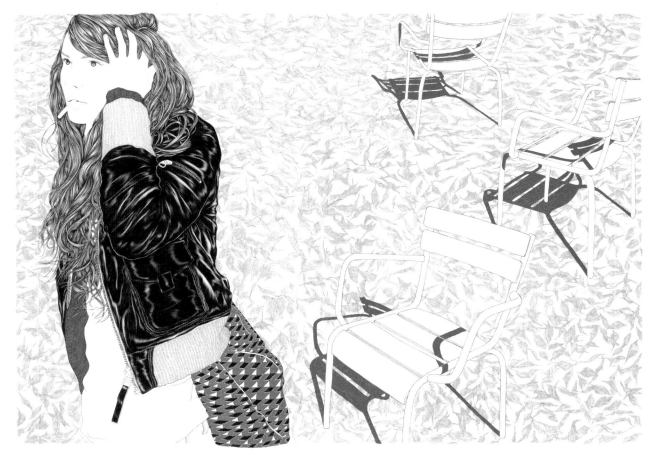

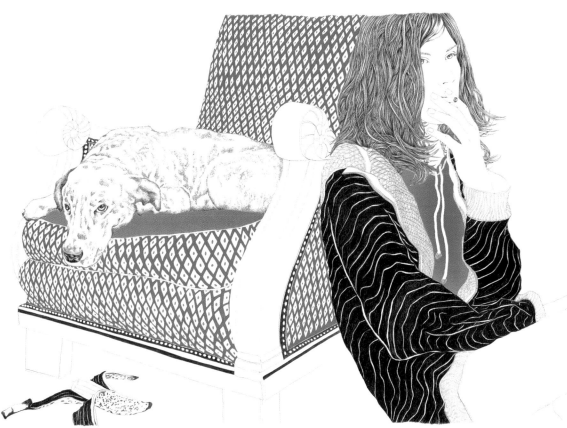

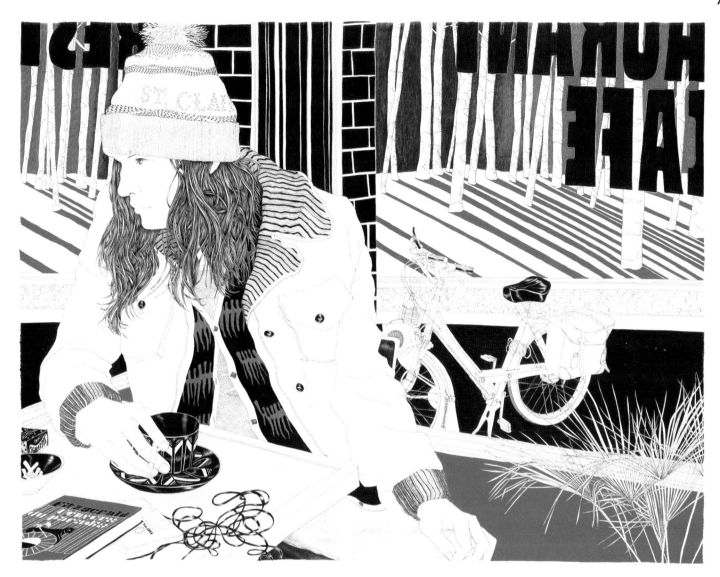

La nuit du doute.
Pen on paper.

From top: p_118
Medicis.
Pen on paper.
Le colloque singulier.
Pen on paper.

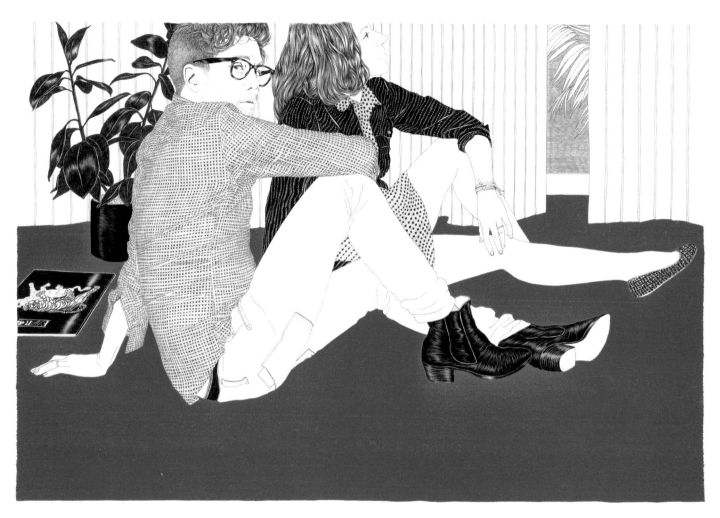

Milano.
Pen on paper.

From top: p_121
Diptyquos.
Pen on paper.
Orléans.
Pen on paper.

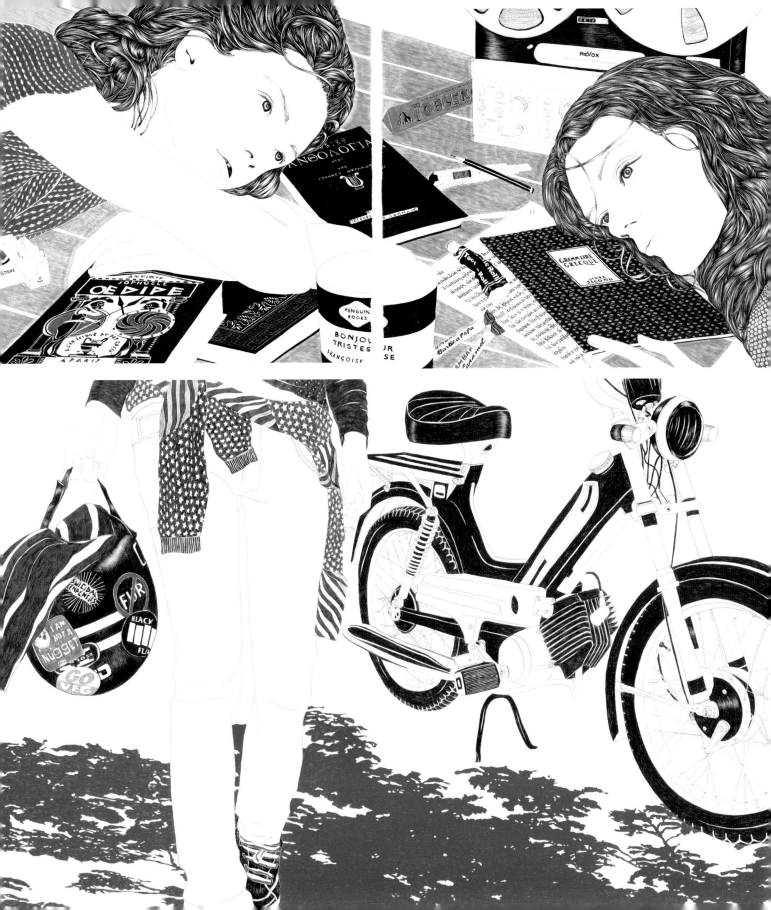

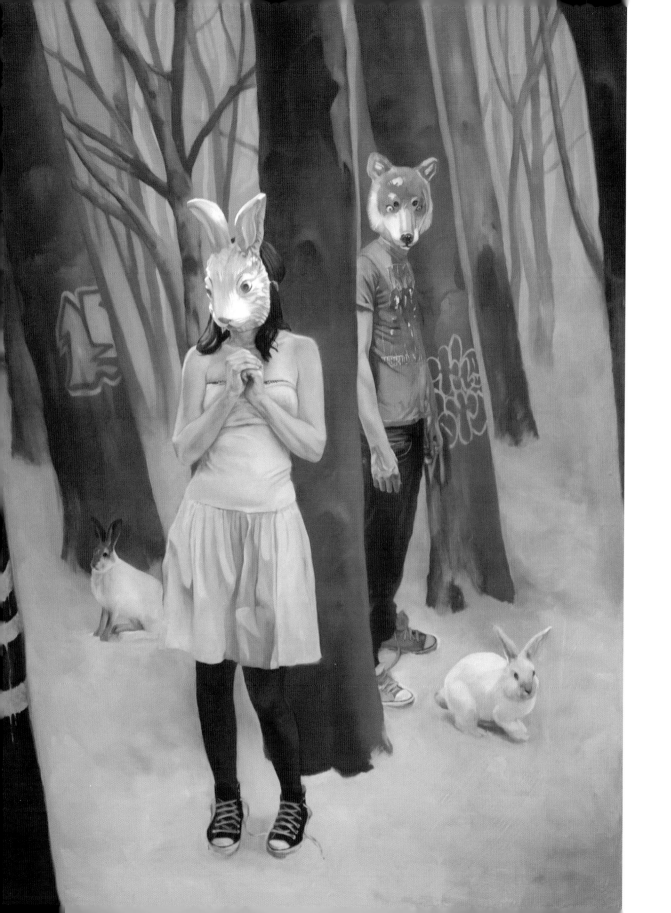

Nate Frizzell

visit: www.natefrizzell.com

Like so many other artists, I was creating art since I was a kid. Twenty-some years later, I'm still a kid but creating art with a little more skill and direction. I studied illustration at Otis College of Art and Design after high school and learned a lot about the basics of painting and storytelling. But I was always drawn to more traditional art and figurative painting. Since graduating, I've attempted to blur the lines between more traditional and illustrative work as I move from one medium to the next pushing myself to get better with each piece.

I am still striving to get where I want to be, technically. I don't know if I will ever reach the point where I am satisfied. I am constantly evolving with each piece as I move on from one medium to the next. But I think skill and technique is learned with time and practice. I believe the idea and inspiration behind a work of art is much more important. While I have always striven to create work that speaks about the human condition, my focus has narrowed along the way to the concept of discovering one's own identity and the obscured paths that follows. As a result, each painting becomes a metaphor for choosing different paths in life, while finding oneself.

Como muchos otros artistas, llevo creando arte desde que era un crío. Veintitantos años después, sigo siendo un niño pero creo arte con un poco más de habilidad y dirección. Después del instituto, estudié ilustración en la Escuela de Arte y Diseño Otis y aprendí mucho sobre lo básico de la pintura y la narración de cuentos. Sin embargo, siempre me ha atraído más el arte tradicional y la pintura figurativa. Desde que me licencié, he tratado de difuminar las líneas entre la obra más tradicional e ilustrativa, mientras me muevo de un medio al siguiente, exigiéndome mejorar con cada pieza.

Aún me esfuerzo por llegar al lugar dónde quiero estar técnicamente. No sé si conseguiré alcanzar alguna vez el punto en el que esté satisfecho. Evoluciono constantemente con cada pieza mientras cambio de un medio al siguiente, pero considero que la habilidad y la técnica se aprenden con tiempo y práctica. Creo que la idea y la inspiración que hay tras una obra de arte son mucho más importantes.
Mientras que siempre me he esforzado por crear una obra que hable sobre la condición humana, mi atención se ha centrado en el camino del concepto por descubrir la propia identidad y los oscuros caminos que sigue. Como resultado, cada pintura se convierte en una metáfora para escoger los distintos caminos en la vida, mientras uno se encuentra a sí mismo.

p_122
Every moment with her was a moment to keep.
Oil on canvas.

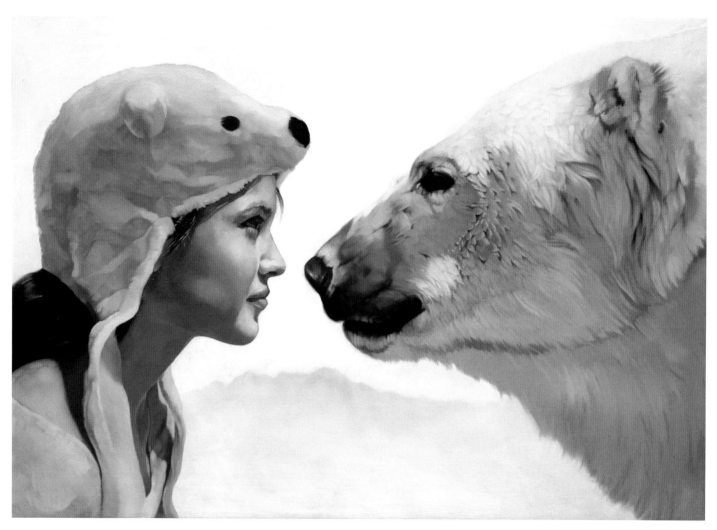

To see her like youd see a star.
Oil on canvas.

p_125
Flying south.
Oil on canvas.

p_126-127
It takes all the running she can do just to stay in he same place.
Charcoal on paper.

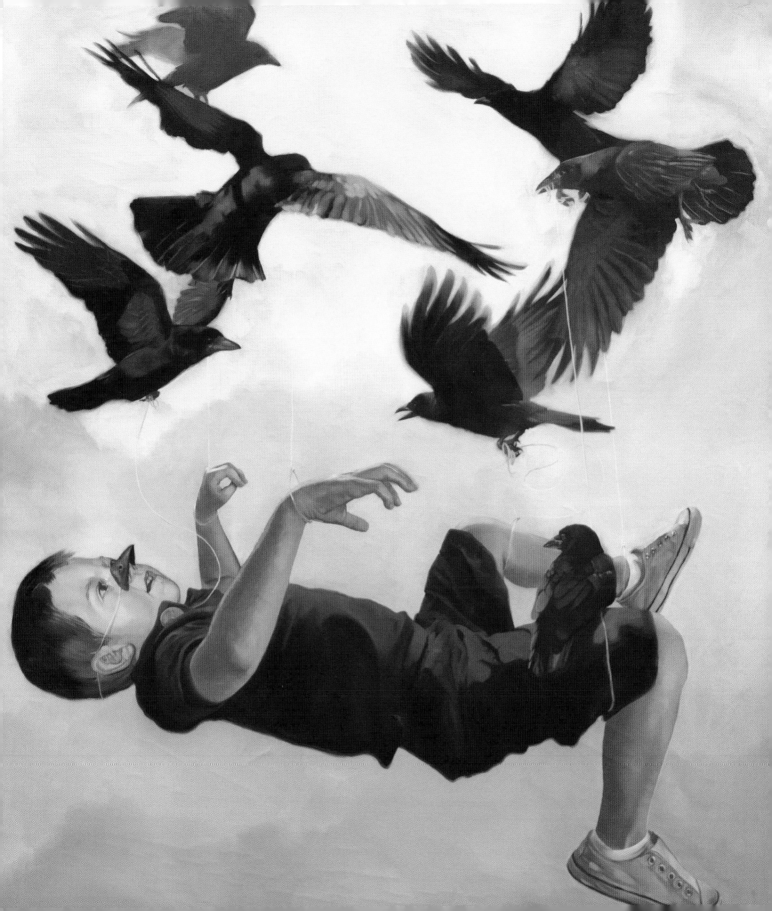

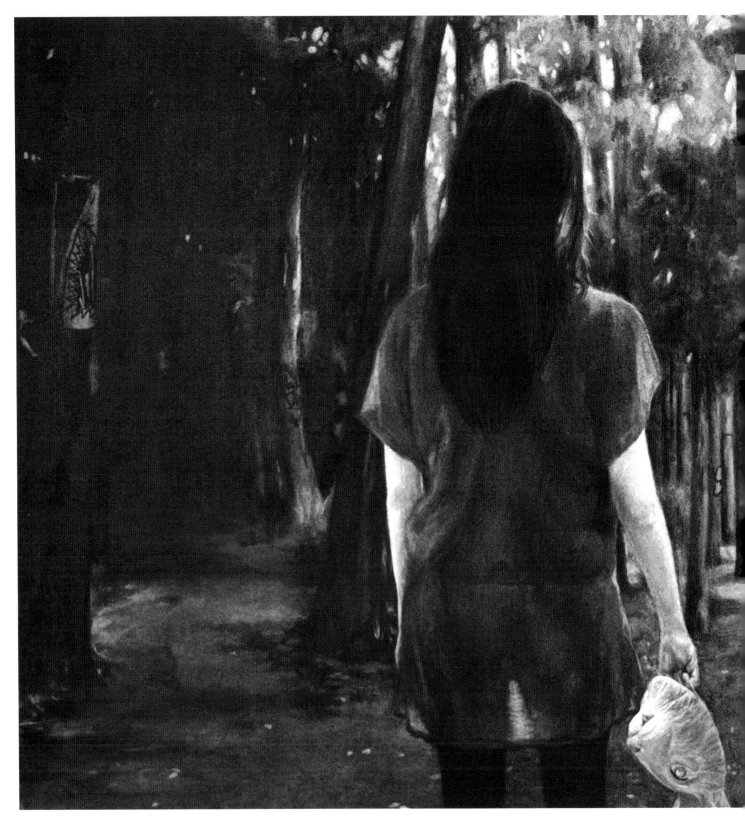

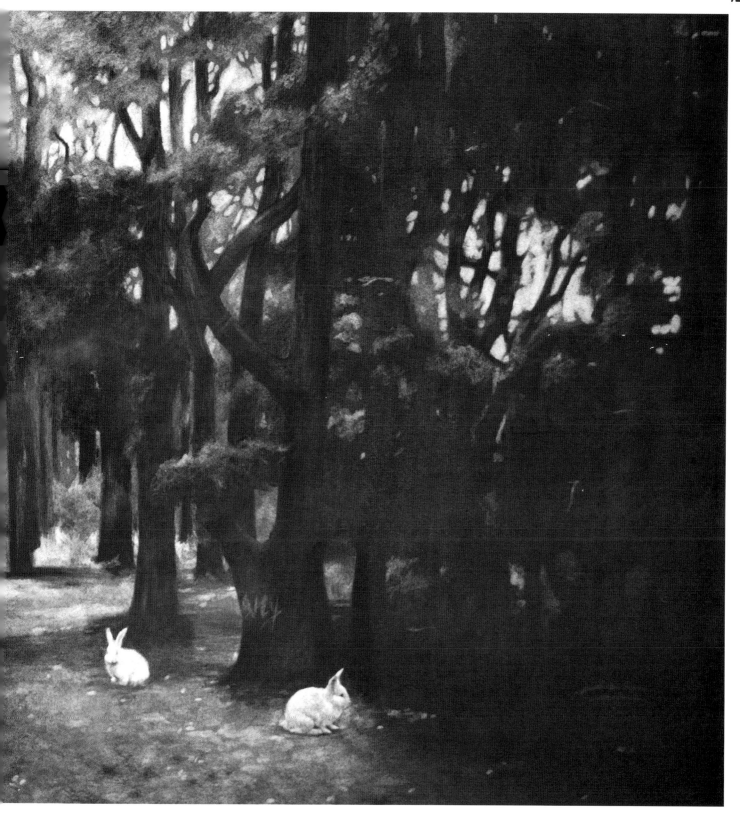

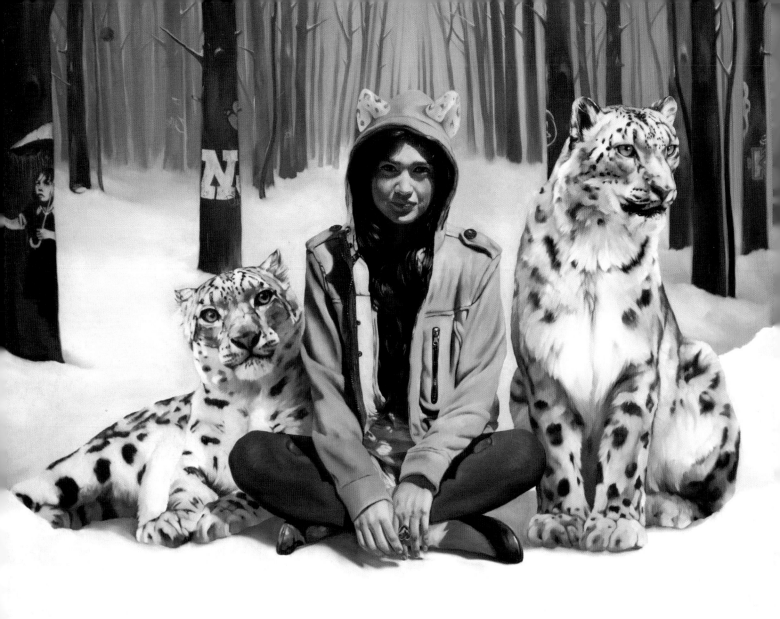

Waiting to be unseen.
Oil on canvas.